Pro Techniques of
STUDIO
PHOTOGRAPHY

Jerry Fruchtman
with Vernon Gorter

Publisher	**Rick Bailey**
Executive Editor	**Randy Summerlin**
Senior Editor	**Vernon Gorter**
Art Director	**Don Burton**
Book Design & Drawings	**Leslie Sinclair**
Managing Editor	**Cindy J. Coatsworth**
Typography	**Michelle Carter**
Director of Manufacturing	**Anthony B. Narducci**

Published by HPBooks, a division of HPBooks, Inc.

P.O. Box 5367, Tucson, AZ 85703
(602) 888-2150
ISBN: 0-89586-384-7
Library of Congress Catalog No. 86-81084
©1986 HPBooks, Inc.
Printed in U.S.A.
2nd Printing

COVER PHOTO: Model and actress Tawny Moyer on a Honda 150 Elite scooter, Scooter courtesy of American Honda. Special thanks to Pete Samuels for his hard work and to Bonnie Steves for her tasteful contribution.

CONTENTS

FOREWORD

You'll see my name linked with several photographs in the Portfolio section of this book. I'm flattered to see reproductions here of a variety of images Jerry Fruchtman shot on assignment for me.

From the outset, I recognized a distinct style in Jerry's work—a style I very much like but find difficult to describe in words. It has something to do with lighting and composition as well as with the distinct way in which Jerry sees things.

No matter how varied the shooting assignments I give to Jerry—food, flower arrangements, furniture or fashion—he unfailingly brings that unique style to his work.

I'm happy to have helped Jerry's career by being able to display his work on the pages of *Home* magazine. Our relationship has been beneficial to both Jerry and the magazine.

I'm delighted to be a small part of this book. To be associated with the photography of Jerry Fruchtman is, indeed, an honor.

Al Beck
Art Director
Los Angeles Times Sunday Magazine

DEDICATION

To Brooke, and to those others who have helped me to grow from within.

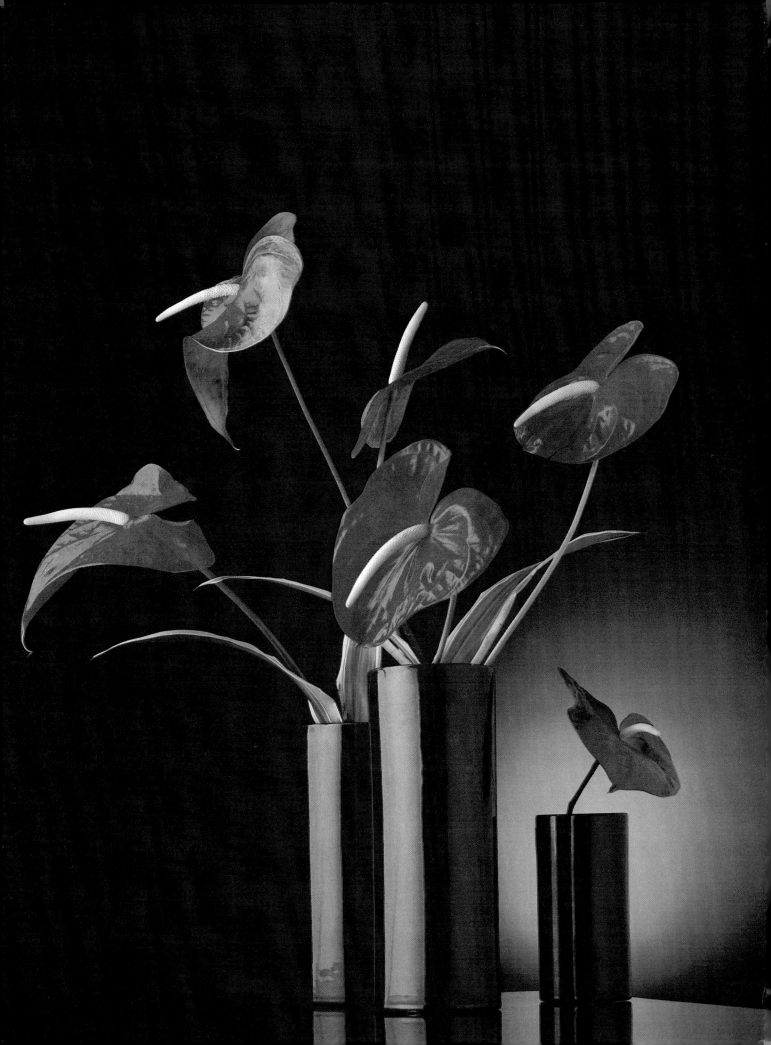

INTRODUCTION

The fact that you're reading this book indicates that you and I have one thing in common: We need to express ourselves visually. Furthermore, we have both chosen photography as our medium of expression.

At the age of about 10 or 11, I fell in love with moviemaking as a potent form of visual expression. I started making home movies. However, I soon realized that the expense was too great to enable me to achieve the satisfaction I wanted.

I also realized something perhaps even more important: Moviemaking is essentially a team activity and I'm not a natural team player. I wanted to make visual expression my livelihood, but I didn't want to do it as a member of a crew or as a cog in a wheel. My form of expression needed to be a personal one.

I turned to still photography. By the age of 18, I was taking my photography pretty seriously. Limited financial means prevented me from engaging in travel photography or from hiring expensive models to photograph. But I could afford to photograph simple still-life subjects.

Although I started doing still-life work out of necessity, it soon became my preferred medium. I have always felt the need to record exactly the effect I had visualized and to produce first-class work consistently. To satisfy those needs, I needed total control. The only place I could find that control was within the confines of a studio.

If traveling is your main interest, consider landscape photography, industrial photography or photojournalism. To me, photographic expression is the main thing, and the place where I do it best is where I have total control—in my studio.

At 21, I enrolled at the prestigious Art Center College of Design in Los Angeles, majoring in photography. At that school, which has since moved to Pasadena, California, I had some excellent teachers and learned a lot.

I have also taken courses in photography at other schools. Many of my school experiences proved disappointing. Many of the things that I felt I needed to know to succeed in the competitive world were not taught. For example, I was taught how to "*shelter* my first million dollars," when I would much rather have been shown how to "*make* my first quarter-million."

Among teachers and students alike, I have often sensed a reluctance to share. It seemed almost as if it involved sacrificing their creative life-blood. Unfortunately, such people were unable to distinguish between technique and creativity. Technique is the domain of all. If one source fails to provide its secrets, you can always find them elsewhere. Creativity, on the other hand, is very personal. No one can steal it from you. Even if they could, it wouldn't diminish your own creativity.

Through this book, I want to share with you my techniques, my experiences, and my philosophy. I want to teach you some things that may be truly helpful in improving your photography. You're welcome to all the information and guidance I can impart.

However, I can't give you my most valuable asset, nor can you take it from me. That's my creativity. You must use your own. Reach deep within yourself, find it, and use it. All your knowledge of theory and mastery of technique should serve this one end. When the creative process goes into action the fun really begins.

This is a positive book. I want to tell you how you can make attention-getting photographs in a studio setting. I want to explain some of the principles involved. However, I'm not going to warn you against things that "can't be done." If you feel that an unconventional lighting setup will give a specific effect, try it. Remember, the bumblebee flies only because it hasn't yet heard the aeronautical engineers tell it that, technically, it can't!

This book is intended mainly for users of 35mm cameras. I do much of my work in this format. I also use 4x5 cameras and, occasionally, 8x10.

The basic photographic principles involved are the same. This is perhaps more true in my case than with other photographers. The reason is that I make minimal use of that added feature of large-format cameras—the swings and tilts of film plane and lens board.

I do use the tilting front for added depth of field. It makes up for what is lost by the use of the longer lenses that go with larger cameras. However, I rarely use camera movements to "correct" perspective. If I'm pointing my camera downward at a subject, I expect the vertical lines to converge. I like to see them that way in my pictures. The rare exception when I record receding lines parallel is when a client—or a layout—specifically demands it.

The essays at the beginning of this book tell you about my photographic technique and philosophy in general. In the portfolio section that follows, you'll learn in detail how each photo in this book was made. ☐

WHY STUDIO PHOTOGRAPHY?

Many photographers use their craft as a passport to an exciting life. They may like to travel, to photograph beautiful women or to meet famous people. I, too, could pack up my cameras and go out and earn my living on such adventures. Why, then, do I limit myself to the confines of my studio? The answer is simple. It lies in the key word, *control*.

TOTAL CONTROL

I don't use my photography to achieve any other end besides making good photographs. To produce good images consistently, I need total control of my medium and the environment in which I shoot. That means I need a studio.

Constant Environment—In my studio, I can produce the precise lighting effects I want. The light will remain the way I want it until I deliberately change it. If I want to, I can re-create the same lighting at a later session. I'm independent of the vagaries of the weather.

Among my background papers and materials, colored gels and selection of lights, I have the makings of an infinite variety of background tones, colors and textures.

Economy—Studio photography is inherently economical. I don't have to hunt for suitable locations or pay location scouts to do this for me. I'm free from the worry of work stoppages due to unsuitable weather and lighting conditions. I've also found that studio photography—whether for advertising, packaging, posters, catalogs or editorial use—is always in demand.

Comfort—I do my best work when I feel comfortable and have nothing to worry about except my photography. In my studio, I'm always warm or cool enough and I know I'll remain dry. I don't have to contend with a well-meaning, but distracting, audience that asks me such questions as, "What's your favorite *f*-stop?"

I have all my equipment and props within easy reach. I don't have to carry them all around—or be fearful that I may have forgotten the most important item.

In my studio, the subject "waits for me." I can leave everything set up while the film is being processed. Sometimes I'll have two or three sets up at the same time.

When I've finished my day's work, I go home. I needn't worry about hotel reservations, flight times or car rentals.

Esthetics—While creature comforts help me to concentrate all my attention on my main interest—photography—there are also esthetic advantages to shooting in the confines of a studio. By taking a subject from its natural or usual environment and bringing it into the neutral context of the studio, I see it more clearly and often in a totally new way. This enables me to bring out the inherent beauty in an object.

Improvised "Location" Studio—When I shoot on location—and there are times when I do—I make every effort to turn that location into an improvised studio. To be sure I have everything I'll need, I tend to take with me three or four times as much equipment as I would normally use in the studio. This includes light, reflectors, backgrounds and props.

On location, I usually use 35mm cameras and shoot at least 10 rolls of 36-exposure film on one assignment—a total of 360 exposures. That's considerably more than I would normally shoot in the studio. I bracket my exposures liberally, relying on a change in shutter speed as much as possible. To retain depth-of-field control, I like to keep the lens aperture constant.

So, you can see that my location work is basically studio photography away from the studio. The reason, as always, is *control*.

THE CREATIVE CHALLENGE

In still-life studio photography, you can't rely on *snatching* that once-in-a-lifetime shot, as the photojournalist can. You don't have the opportunity to *record* the most sensational sunset you've ever seen. You can't *rely* on the beauty or character of your subject, as can the portrait photographer.

My raw materials are inanimate subjects. My tools are my imagination and creativity. I must *create* every single image from scratch. That's the challenge, and the excitement, confronting the studio photographer of still-life subjects. Of course, I photograph people, too. But they are usually secondary to the product or object I'm illustrating.

A handful of individuals and one famous organization have had domi-

nant influences on my thinking and on my approach to my work.

PENETRATING THE SUBJECT

Other than perhaps in his fashion photography, you rarely see an Irving Penn photograph in which his main preoccupation seemed to be the combination of several subjects into one pleasing composition. Usually, his main concern seems to be to isolate one central subject and bring out its essential characteristics. Although my basic lighting technique differs considerably from Penn's, I have learned from him how to use light and simplicity of design to bring out the basic character of an object—be it a flower, a bottle, a shoe or a gardening tool.

Even when Penn photographs people, he rarely places his subject within the wider context of an elaborate composition. He concentrates directly, and penetratingly, on the subject.

Irving Penn's work has been published widely over several decades in magazines and books. Many fine examples of the effective revelation of the essence of a subject can be found in his book, *Flowers*, published in 1980. A close study of the many beautiful color plates is well worthwhile for the student of still-life photography.

Bass taught me the "why" of what I do. He showed me the importance the *thinking* process played, even in *creative* visual work. It has become almost intuitive for me to only take steps in my photography that have a specific reason. This does not mean my photography has become nothing more than an intellectual exercise. The creative process always comes from my *feelings*. The manner in which the process in realized on film comes largely from *reasoning*.

HOW TO USE COLOR, FORM AND SPACE

Louis Danziger, a well-known Los Angeles designer and head of the California Institute of the Arts in Northridge, has also taught me some useful lessons. He has a large collection of posters—graphic and photographic—going back over many years. He has spent many hours going through these posters with me.

From this experience I learned how to effectively interrelate color, tone, form and empty space—also known as *negative space*—in my compositions. Lou Danziger brought me the realization that, often, "Less is More."

The axiom that less is more originates from Mies van der Rohe, an in-

ucts, and even photography. That influence is still visible today in the design of high-rise buildings, the form of chairs, the shape of utensils—and style in the graphic arts.

DESIRED EFFECT DETERMINES TECHNIQUE

The essential Bauhaus philosophy was that art can be more than merely esthetic and exclusive to the few. Art could be functional and thus serve all in their daily lives. The basic Bauhaus tenet was that "Form Follows Function." This means that the *function* an object is to serve determines its *form*. In that sense, "form" includes both the materials used and the manner in which they are shaped.

The Bauhaus tenet doesn't apply only to the design of chairs, cars and buildings. It applies equally to the "design" of photographs. I determine the *function* of a photograph. For example, I may want to emphasize the transparency, delicacy and texture of crystal glass. I then determine the most effective way to give that image *form*. The most important part of this is the character and direction of lighting and the tone of the background.

Function determines form: I apply that thought in my work almost daily. My aim is to bring out the essence of the subjects I photograph. I want to record them not only the way they *look*, but the way they really *are*. By this I mean that when you look at my photograph of the crystal glass you don't simply see glass. You *feel* its delicacy, the smoothness of its base, the texture of its sides, and even "hear" its ring when you touch glass to glass.

STUDIO OFFERS WIDE CREATIVE HORIZONS

Don't for a moment think that limiting myself to the confines of a studio means that I'm confined to repetitive and boring work. In the course of a month I photograph electronic components, food, flowers, jewelry, furniture, furnishings, tableware, silverware and a host of other varied sub-

Thinking plays an important part in creative visual work. This does not mean that photography is nothing more than an intellectual exercise. The creative process always comes from feelings. The manner in which the process is realized on film comes largely from reasoning.

THE THINKING PROCESS

Saul Bass is one of the country's finest designers. His wide range of activities has included designing movie titles, products and logos for leading corporations. To give just one notable example, he is responsible for the famous AT&T logo. When I first left school, I had the good fortune to spend some time working with Saul Bass and I still have professional contact with him.

fluential architect during the early years of this century. Van der Rohe was closely associated with the *Bauhaus,* an organization that has had a profound effect on my thinking.

The Bauhaus, founded in 1919, was a school of design in Germany. During the brief years of its existence, before Hitler closed it as being incompatible with Nazi philosophies, the Bauhaus influenced design in many areas, including architecture, graphics, prod-

jects. I photograph subjects alone or with human interest. I make realistic images and create abstract designs.

Some of my work is intended for advertising, some for publicity, and some for annual reports. I produce images for posters and for illustrations on packaging. Many of my pictures have appeared in the editorial sections of magazines—local, national and international.

Unusual Challenges—Some of the challenges I face are unusual; others border on the farcical. For an assignment for AT&T, I was once required to build a flooded basement in my studio. A contained area, furnished with washers, dryers, shelves and other appropriate props, was flooded to a depth of about one foot. Everything went well during the preparation and the shooting.

When we came to break up the set, the tarpaulin "pool" holding the water broke—and my studio was *really* flooded!

On another occasion, I was assigned to dramatize the use of a security system that would inform a store owner of disaster. We filled a freezer cabinet with 200 dollars' worth of ice cream and food. We left the freezer at room temperature and waited for a molten mess to ooze from the freezer. We then photographed the result. You can imagine the fun of the clean-up operation!

One art director needed a shot of the back of a car, with the rear lights on. To create dramatic back lighting, I had constructed a complex lighting setup on the car's hood. It took some time to get the lighting and composition right and to make a few test shots. When the time finally arrived for the actual shooting, the car's lights suddenly failed. The car battery was dead. The only way to replace it was to dismantle the entire lighting setup!

I remember the occasion when I spent three days trying to get oil from three holes in a can to pour to a common point on a table. The client wanted it that way—in defiance of the basic laws of nature. Somehow, we achieved what he wanted!

I always aim to produce what the art director or client needs. Sometimes what he *needs* and what he *wants* seem, to me, to be different things. In such a case I will honestly say so—but never without offering a workable alternative. In my mind, I have completed a truly satisfying assignment *only* when *both* the client *and* I are totally satisfied with the result.

> *Within the confines of the four walls of my studio, I may not be able to look toward the distant horizon. But my creative horizons are unlimited. You can have the same unbounded adventures in the private photographic world that is a studio.*

There are rare occasions when I'm asked to produce images for which photography is not the ideal medium. I'm a visual problem solver. One of my responsibilities in that role is to know when the medium is unsuitable. When such a situation occurs, I ask the client or art director to consider a different approach to the assignment. I may suggest that an illustrator, rather than I, do the job.

SHOOTING FOR FUN

It's important for me to occasionally take pictures simply for fun—not as a required assignment. At those times, I like to shoot subjects that are very different from my usual work. For example, I have for a long time been fascinated by old diners at night. I have taken many pictures of these structures, which are very varied and often quite quaint. The lighting can be very different and often dramatic.

Strangely, I find that such photographic diversion often results in new ideas and boosts my creative potential. This, in turn, makes my studio work all the more effective.

BE DARING AND EXPERIMENT FREELY

While I'm within the confines of the four walls of my studio, I may not be able to look toward the distant horizon. But my creative horizons are unlimited. You can have the same unlimited adventures in the private photographic world that is a studio.

Be daring! Follow the advice of Josef Albers, another prominent Bauhaus member: "To experiment is at first more valuable than to produce." Break the conventional rules when it enables you to achieve the desired effect. In other words, use any *form* necessary to serve an intended *function*.

Be deliberate in whatever you do. Carter Ratcliff, who was a contributing editor to the former *Picture* magazine, once said, "All of us, no matter how unconsciously, glamorize what we see." However, if you want to glamorize what you *photograph*, you have to do so very *consciously*.

As you photograph, remember what works and what doesn't. Stick to the methods and techniques that give you the results you want. Discard the rest. But don't limit yourself to the tried and trusted ways. The inventive and controversial French painter, Marcel Duchamp, once said, "I constantly contradict myself in order to keep myself fresh."

I urge you to do the same—perhaps not constantly, but certainly from time to time. I do the same. It helps make my every entrance into my studio the start of an exciting adventure. □

2
THE STUDIO

For me, the first requirement of a studio is that it provide me with total creative control. This means that it must be possible to keep out all extraneous light during a shooting session. It must also provide enough space, not only for the objects being photographed, but also for creative camera, light and background placement.

As an amateur photographer, you can convert a room in your home for use as occasional studio. Or, you may be able to set aside a room as permanent studio space.

As a professional, you must determine what your space requirements are going to be and what you can afford. If you plan to work in your home, keep your studio facility as separate from regular family activities as possible, at least during actual working hours.

Obviously, you'll need much more space if you're going to photograph cars and boats than if your business is mainly food or flower photography.

I'll describe my studio facilities for you and explain why I need the space and facilities I have. This should help you evaluate your own needs.

RENTAL

Don't lease studio space until you truly need it and can afford it. Until that time, make do with space in your home, even if it is a little inconvenient.

When you start renting, a commonly used guideline says that your monthly rental should not be more than 10% of the amount your business generates during an average month.

SPACE

If you were to visit my facility in Los Angeles, you would be surprised at the size of my studio. It's very large. You may wonder why a still-life photographer, who normally photographs relatively small sets, needs so much space.

There are several ways in which a large studio enables me to do creative things I couldn't achieve in a smaller space.

Ceiling—My studio ceiling is about 30 feet high. This gives me great freedom of movement with my lights. It also prevents unwanted reflection of light onto my subjects, thus giving me more control of the effect created by the illumination.

For extra control, I have constructed an adjustable ceiling. This consists of a large, translucent, backlit light bank. It could also be made from large, white board or paper, to act as a large reflecting surface. My ceiling device is so constructed that it can be raised or lowered easily. It can also be tilted.

If your studio ceiling is relatively low, I suggest you place your subject on the floor or near floor level when you need additional height for your lights. To prevent unwanted reflections, paint a low ceiling black. Should you want to bounce light from the ceiling, you can always attach a sheet of white seamless paper or a white card to the ceiling temporarily.

Floor Space—As you'll see from several of the photos in the portfolio section of this book, I often like to create a strong graphic effect by compressing the feeling of distance and minimizing perspective in my photos. This demands the use of a long lens and a relatively great camera-to-subject distance.

Even when I'm photographing relatively small subjects, such as food, flower or jewelry arrangements, I often need a substantial studio length. My usable space is about 40 feet long.

For creative light placement, and to avoid unwanted reflection onto the subject, I need the 25-foot studio width I have. With a 9-foot seamless background and a 5-foot space for lights on each side, I need a minimum width of 19 feet. The additional six feet make my work a little more convenient and easy.

ACCESS

As important as the size of the shooting area is the access to the studio. There's no usefulness in having a studio large enough for a car or boat if you have no way of getting those objects into the studio.

My studio is on the ground floor. I had a large drive-through door built into one wall. It enables very large objects, such as vehicles, to be brought in. My first assignment requiring that door was to photograph a TV antenna dish 12 feet in diameter.

We brought the dish into the studio fully assembled. Had it needed dismantling and reassembly in the studio, I'm sure another studio would have been given the assignment. That one assignment fully paid for the door!

WINDOWS AND SKYLIGHTS

Some photographers value a north-light window or skylight. I prefer not to use daylight in my studio because it's too variable. As I've indicated before, my whole purpose of shooting in a studio is to get total control. North light also tends to be bluish, calling for corrective filtration.

My studio happens to have two large skylights. They are wonderful while I'm not shooting. They provide bright illumination for preparatory jobs such

as constructing sets and setting up a shot. On a sunny day, they also add a bit of cheer to the studio. However, when the setting up of lights begins, I close the skylights tightly!

When no daylight enters the studio, and only the modeling lights of my flash units are on, I can control the effect of my lighting very precisely.

BACKGROUNDS

The variety of backgrounds you can use for your still-life photography is limited only by your imagination. Paper, tiles, wood, stucco walls, translucent plexiglass and aluminum foil are just a few examples. Backgrounds can be divided conveniently into the following three groups.

Fixed Background—The fixed backgrounds in my studio include the walls. To get a large, uniform background—larger than any paper rolls can provide, I have had a 25-foot-wide cove constructed between floor and one wall. This continuous sweep from floor to wall provides a seamless background for very large subjects. No ugly dividing line between wall and floor cuts through my pictures. To maintain a clean background, I regularly repaint the cove and the wall and floor space adjacent to it.

A vertical cove between two adjacent walls can be equally useful for subjects that occupy a lot of height.

With a little imagination, I can use other fixtures in my studio for backgrounds. They include doors and pillars. Sometimes I need to do a little painting or make other modifications to achieve the effect I'm after.

Movable Background—The most commonly used movable background is seamless paper. This plain paper is available in rolls up to 12 feet wide in white, gray and black and up to nine feet wide in many other colors.

Seamless paper rolls can be suspended from a wall. In addition to a wall fixture, I have a couple of movable stands for seamless paper. They give me more flexibility with background placement. Equally important,

they enable me to use the paper as strategically placed reflectors.

Other movable backgrounds that I often use—as you can see from many of the photos in the portfolio section of this book—include translucent materials, either backlit or not, and actual light banks.

Sets—Sometimes, more than just a plain background is called for. In such a case, I'll have a *set* constructed. It may consist of a window ledge and window, a fireplace, a kitchen counter or a bookshelf. Sometimes existing furniture and props make up a set, at other times a set has to be specially constructed. This may call for the help of a professional carpenter.

Store a Variety of Backgrounds—As far as your space permits, I advise you to keep a wide variety of possible background materials. Items you have used as backgrounds before will come in handy again in the future. Often, materials used originally for quite a different purpose make wonderful backgrounds, too.

models and entertain clients during shooting sessions, it's essential that you have comfortable and cheerful facilities for them. You should have adequate dressing and makeup areas for models and a comfortable reception area for clients and models. In addition, good bathroom facilities are essential. Also, it's a good idea to have liquid refreshments on hand for your guests at all times.

Make a careful distinction with what you need and what you would like to have. For example, in my work I only rarely use professional models. Therefore, I don't have permanent dressing rooms. I can put the space to better use. When I need a changing area, I construct a temporary one with screens.

UTILITIES

Adequate electrical supply is essential to the operation of an efficient studio. Water and effective sewerage are also important, especially if your facility is to include a darkroom.

I like to create a strong graphic effect in many of my photos by compressing distance and minimizing perspective. This demands a long lens and a great camera-to-subject distance. For creative light placement, I need substantial studio width. That's why I have a studio that measures about 40x25 feet.

HIGH VIEWPOINT

Earlier, I mentioned the advantage of a high ceiling for light control. A high ceiling also enables you to place your camera high, for a vertically downward viewpoint.

You can shoot from a high ladder, with the camera on a tall stand or tripod. I have a balcony, which is much more convenient. However, this is certainly not a necessity and, in fact, you rarely find premises that offer it.

MODEL AND CLIENT FACILITIES

If you're going to use professional

Electric Supply—Be sure your wiring is adequate to take the maximum load you're likely to put on it. If you're always in doubt whether you might overload the system, your shooting sessions will be frustrating. In calculating your maximum load, include more than your lights. Remember that your water heater, air conditioner, microwave oven and other appliances also drain electricity.

Consult a professional electrician. Several years ago, I found it necessary to spend in excess of $3,000 to have my power supply brought up to par, even though my studio is located in

commercial premises. It's been well worth it—in peace of mind alone.

Water—If you include a darkroom with your studio facility, you'll need water supply and appropriate plumbing. Here, too, it pays to have professional advice.

Keep a wide variety of possible background materials. Items you have used as backgrounds before will come in handy again in the future. Often, materials used originally for quite a different purpose make wonderful backgrounds, too.

Even if you don't need a darkroom, you're likely to need water. I do a lot of food photography and so need a kitchen which, obviously, calls for water. You also need good bathroom facilities, especially if you're going to use professional models and have clients present at shooting sessions.

For darkroom use, I advise you to install effective water filtration.

Waste Disposal—If you're going to dispose of chemical waste from a darkroom, consult with a plumber regarding the best type of plumbing.

Communities generally charge a fee for waste disposal from photo labs. If you do only occasional darkroom work, you'll generally be exempt from such a fee.

Photographic waste should not be disposed of in septic tanks because it hampers their proper function.

RENT IT OUT

No photographer shoots 100% of the time. I can regain a considerable proportion of my studio rental cost by renting out the studio to other photographers. Many photographers require a large shooting area occasionally but not often enough to rent a large studio permanently. I can earn about $3,000 per year by renting out my space.

BUILD IT UP BIT BY BIT

What I've told you about my studio may seem totally unreachable to you. However, bear in mind that I have progressed slowly to where I am now. Today, I have enough work to need every bit of the facilities I have. I advise you to do what I have done: Build up your studio bit by bit. As you need new space or facilities, add them. When you truly believe that you need them, chances are you'll also be able to afford and justify them.

I have put tens of thousands of dollars into my present studio. How much you put into yours depends on your tastes, your requirements and your means. The only really useful, universally applicable advice I can give you is this: Whatever you plan, it's likely to cost twice as much as you initially estimate and take about three times as long to complete. This is not intended to discourage you, but only to give you a realistic piece of advice, based on personal experience. Bear it in mind as you plan and budget for the future. □

BASIC EQUIPMENT

In this essay, I discuss the basic photographic equipment I use. This includes cameras, lenses, camera supports and studio furniture. Lighting equipment and techniques will be covered in the following two essays.

CAMERAS

I use 35mm SLR cameras for nearly half of my work. The ease and speed with which I can shoot with my Nikon cameras is particularly suitable when people are included in my shots. However, because today's films and lenses offer such excellent image resolution, I have no reservations about shooting much of my still-life work in the 35mm format.

Occasionally, a client will ask me specifically to shoot in the 2-1/4-inch-square format. I have a Hasselblad camera for such occasions. However, I wouldn't normally use it of my own choosing. When I compose and frame the image, I like to be looking toward the subject and not downward into a waist-level viewfinder.

A more important drawback is the left-to-right reversal of the image in the viewfinder. For me, image composition includes the consideration of what is to be on the left side and the right side of the image.

For example, because we are accustomed to reading from left to right, an image that suggests movement toward the right will generally appear more dynamic than one that suggests movement to the left. Seeing in the viewfinder *precisely* what will appear in the final picture helps me to compose an image effectively, decisively and quickly.

From personal experience, I'm convinced that Kodachrome 25 and Kodachrome 64 film, together with the excellent lenses I have for my Nikon 35mm SLR, provide images better than can be obtained in 2-1/4-inch-square cameras with Ektachrome film.

The 4x5 format is my choice for probably more than half of my photography. Many clients prefer the large image provided on 4x5 film. It enables them to evaluate pictures more easily than on 35mm film.

I use my 4x5 Sinar view camera for all my poster photography. Pictures shot for posters are enlarged considerably, so the image must be as sharp and crisp as possible. The 4x5 format is also my favorite when minute detail is to be recorded.

When I need camera movements—the ability to swing or tilt the film plane in order to control perspective—I also use the Sinar. A 35mm camera offers only limited perspective control, and only when a special PC (Perspective Control) lens is used.

The largest format normally used by professional photographers is 8x10. I use it occasionally—when I feel the extra image quality obtainable warrants the cumbersome equipment and somewhat difficult use. Occasionally, a client will insist on the 8x10 format.

Because the 8x10 format demands accordingly long lenses with relatively small maximum apertures, they make image focusing difficult. My personal conviction is that, taking into consideration the excellent quality of 4x5 film and lenses for 4x5 cameras, and the awkwardness of using an 8x10 camera, I can get just as good results with my 4x5.

Because I need to shoot on 8x10 film only rarely, I don't own this equipment. When I need it, I rent it. In the Los Angeles area, I can easily rent an 8x10 Sinar camera, two lenses, 15 sheet-film holders (each designed to hold two sheets of film) and a Polaroid 8x10 film holder and processor. The rental per day is about $100.

LENSES

Generally, I tend to use the standard lens for any specific format less than a moderately wide-angle and short telephoto lens. For example, for my Nikon I have 28mm, 35mm, standard 55mm macro and 105mm lenses. The ones I use most frequently are the 35mm and the 105mm. Occasionally, I'll need a 200mm or 500mm lens. When I do, I rent it.

My 28mm and 35mm lenses are perspective-control lenses. They provide a limited amount of the movements—or perspective controls—found on 4x5 and 8x10 view cameras.

For the 4x5 format, I have 60mm, 90mm, 210mm and 250mm lenses in addition to the 150mm standard lens. The ones I use most often are the 90mm, the 210mm and the 250mm.

I like to use wide angle lenses when the camera viewpoint is at an angle to the subject. The closer shooting distance made possible with a wide-angle lens emphasizes perspective. The telephoto lenses serve exactly the opposite purpose. When I shoot a subject head-on and want to create a strong two-dimensional graphic effect I'll use the longer lenses. They minimize the effect of image depth and perspective.

Zoom lenses play virtually no part in my work. I think they are ideal for photojournalists and news photographers, who must work fast and yet frame an image properly. In my studio

work, I have time to change lenses and I'm convinced that, good as they have become in recent years, zooms cannot match fixed-focal-length lenses for quality. This is especially true in my work, where sharpness over the entire image area is often essential.

POLAROID FILM BACKS

I frequently use Polaroid film for testing composition and exposure before making the final shot on conventional film. Not only does the instantly available Polaroid test tell me what final adjustments to make, it also enables a client to evaluate the shot and suggest alterations before I make the final image.

BINOCULAR VIEWER

As I indicated earlier, I don't like the left-to-right reversal of the image in a 2-1/4-inch-square camera. Obviously, I dislike the upside-down and reversed left-to-right image in the ground glass of a view camera even more. To correct this, I regularly use a binocular viewer. Viewing the ground glass through it gives a right-reading image. Binocular viewers are available where large-format cameras are sold.

I tend to use the standard lens less than wide-angle and telephoto lenses. I use wide-angle lenses to emphasize perspective when the camera viewpoint is at an angle to the subject. Telephoto lenses serve the opposite purpose: They can create strong two-dimensional, graphic effects with a subject that's shot head-on.

IMAGE DIFFUSERS

Occasionally, I want to create a soft-focus effect or diffuse the image a little. I don't own special soft-focus lenses. I achieve a soft effect by either stretching a piece of black nylon—from a stocking—over the camera lens, smearing petroleum jelly around the edges of a clear-glass filter, or fogging the lens by breathing on it just before making the exposure.

An image can be softened by the above method or using a conventional soft-focus filter, by using soft light, or a combination of both.

Putting a diffuser on the camera lens causes highlight areas to spread into adjacent shadow areas. Using a diffuser on an enlarger when printing negatives has the opposite effect—the shadows will tend to spread into adjacent highlight areas. A creative photographer must decide which effect he wants.

CAMERA SUPPORT

I use a tripod whenever I can. It helps me to compose, focus and frame an image accurately and ensures steady images, even when I'm not using flash. My sturdy studio tripod is capable of supporting any camera from the 35mm Nikon up to the 8x10 Sinar. With extensions, the tripod can be raised to a height of 15 feet. The tripod has a pan-and-tilt head for easy camera aiming and accurate image composition.

There's also a side arm. By mounting it to the lower part of the tripod's center column, low-level photography is made easy.

When several people—models, clients and assistants—are moving around a studio, it's easy for a tripod to be knocked over accidentally. I safeguard against this by "sandbagging" my tripod. I simply hang a heavy sandbag from the center column, between the tripod legs. You can buy sandbags or substitute by filling a large plastic bottle with sand. Using a bottle with a handle makes it easier to tie the bottle to the tripod.

CLAMPS

I always have several clamps within reach. Some have hinges or ball joints for easy adjustment. The clamps are invaluable for supporting reflectors as well as lights.

BEAN BAG

Sometimes I need to shoot from floor level. In such a case, a bean bag is an ideal camera support. A bag of appropriate size is half filled with beans, buckshot or ball bearings and sewn closed. The camera can be placed on it and angled as desired. Although not as firm a support as a tripod, a bean bag is an excellent makeshift in situations where using a tripod is not practical.

BACKGROUND VARIETY

In addition to the backgrounds discussed in the previous essay, there are many other accessories and materials that make excellent backgrounds. For example, colored gels placed in front of lights can be used to project exciting backgrounds onto seamless paper. Or, you can use a variety of cutout shapes for projecting interesting patterns onto a background. A common background effect is achieved by shining a directional light onto seamless paper through a venetian blind. You can also project foliage onto a background. Or, simply use the abstract pattern formed on a painter's dropcloth after several uses. There are endless opportunities.

Backgrounds of projected slides are common, although I rarely use them. The results tend to look artificial unless flawless technique is used—either in projecting the image from behind a screen or from the camera side of the screen.

It's also essential to select an appropriate slide. For example, don't project a scene taken in direct sunlight, with shadows falling toward the right, when your studio setup has the main light on the right side of the camera, so the shadows fall toward the left. Also, don't combine direct sunlight on the

projected background scene with soft, shadowless lighting on the studio subject.

STUDIO FURNITURE

Perhaps my most useful piece of studio furniture is a 4x8-foot table. It's on wheels that lock and is sturdy enough to hold two motorcycles. I also have two pairs of folding sawhorses, together with sturdy support boards. I can use them for supporting an actual setup to be shot or for holding accessories to which I need ready access.

To save valuable space, I have several items in my studio that serve double or multiple purposes. For example, my coffee table contains my filter-storage space.

I always have a 6-foot-tall stepladder at hand. When I'm working with a long lens, I often need more height than that ladder affords me. I have ready access to much taller ladders in the building where my studio is located.

In addition to the items mentioned, my studio storage space contains a lot of wooden blocks, wooden planks, museum wax, gaffer's tape, masking tape, two-sided tape and a couple of rolling tool carts.

RENT FOR OCCASIONAL USE

As I mentioned earlier, I rent 8x10 equipment when I need it because I don't use it very often. I also rent lenses that I need only rarely. I recommend renting any costly photographic equipment or props that are going to be needed only occasionally.

The value of new equipment decreases rapidly. Having it lying around occupies valuable space and doesn't do it any good. So, if you don't need to own it—and if it can't earn its keep on a regular basis—don't buy. Rent instead. I pass my rental charge on to my client as a legitimate expense. ☐

4
LIGHTING EQUIPMENT

Right alongside competent camera technique, effective lighting is one of the essentials of good photography. In the next essay, as well as with the photos in the portfolio section, I explain some of the lighting methods I use for different kinds of subjects to achieve a variety of effects. Before I go on to technique, however, something should be said about the equipment that makes it all possible. Studio illumination generally consists of electronic flash or tungsten lights.

ELECTRONIC FLASH

I use electronic flash for most of my work. There are several manufacturers of excellent flash equipment. I have chosen equipment from Norman Enterprises, Inc. The company is located in Burbank, not far from my Los Angeles studio. This ensures me good and rapid service at all times. I also use Dyna-Lite flash equipment.

ADVANTAGES

Electronic flash has many significant advantages over tungsten illumination.

Short Duration—The duration of an electronic flash is very short. It's short enough to prevent virtually all image blur due to subject or camera movement during exposure.

High Power—Although the flash duration is very short, the power output is high enough to enable you to use a relatively small lens aperture under most normal shooting conditions. This means you can achieve great depth of field.

No Heat—Unlike tungsten lamps, electronic flash gives a lot of light with almost no heat. Most of the little heat generated comes from the built-in tungsten modeling lights. Because flash is basically cool, you can shoot for longer periods without the danger of subjects such as food or flowers spoiling rapidly. Because little heat is generated, you and everyone else in your studio are comfortable throughout a shooting session.

Color of Daylight—Electronic flash is balanced for use with daylight films. This makes it easy to use flash in combination with daylight. For me, that's not an important asset. What is significant for me is that it enables me to use Kodachrome 25 and Kodachrome 64 films—both daylight-balanced films and, in my estimation, the very best color slide films available.

Consistency—An electronic-flash tube gives consistently bright light during the life of the tube. The color of the light also doesn't change noticeably during the tube's life. Tungsten lights—with the exception of quartz-halogen lights—produce illumination that becomes dimmer and more reddish as the lamps age.

Control—I can control the brightness of the illumination at the subject position from each flash head without having to change the light-to-subject distance. I do it by adjusting the power setting of the unit. If I were to adjust the power output of a tungsten lamp, the color balance of the light would be affected. With electronic flash, power adjustment does not produce a color change.

Economy—On average, flash tubes are good for thousands of flashes. This makes them a very economical means of illumination for the photographer who does a lot of indoor shooting, in spite of the relatively high initial purchase cost.

Dependability—A good, professional electronic flash outfit rarely breaks down. If you own a spare power pack and some extra flash heads, you can be virtually certain of losing no shooting time due to flash-equipment failure.

TEST NEW FLASH UNITS FOR COLOR BALANCE

Color characteristics can vary from one flash unit to another. For example, I find my Norman lights give a warmer, more reddish light than my Dyna-Lites. When you get a new flash unit, it's wise to make some test shots of a typical subject, together with a gray card and a color test chart. Establish what light-balancing or color-compensating filters you may need, if any, to achieve the color effect you find best.

MODELING LIGHTS

Because the duration of electronic flash is very brief, you can't see the effect of your lighting until you see the finished photo. That's an unacceptable situation for most professionals. For this reason, professional flash equipment has built-in modeling lights. They are relatively weak tungsten lights, mounted in the flash heads near the flash tubes.

The modeling lights are weak enough to not affect the flash exposure or the color balance in the finished photos. They are bright enough, however, to give a photographer a clear indication of what his lighting is going to achieve.

The modeling lights are easiest to use if you exclude all light that isn't part of the subject illumination from the studio. That's one reason why I

work with no daylight entering my studio.

Occasionally I have exploited the warm quality of the tungsten modeling lights by making the actual exposure with these lights alone. Of course, this is only feasible with subjects that are suitable for long exposure times.

TUNGSTEN LIGHTS

I use tungsten lighting so rarely that I don't own any. I rent it when I need to use it.

EASY CONTROL

Tungsten illumination—which can be in the form of conventional floods or spots, or tungsten-halogen lamps— also has its advantages. The main one is easy visual control.

You see brightly and clearly the lighting effect you're going to get in your pictures. This makes tungsten illumination ideal when very precise light placement is essential. For the same reason, tungsten lights are also ideal for teaching lighting technique.

The modeling lights in flash heads do an excellent job. However, except when the flash is used in a softbox, they do not normally show the precise lighting effect that will be achieved. Even with a softbox, the relative power of different modeling lights doesn't necessarily correspond to the power of the flash units they represent.

A word of caution: When using tungsten lights to visually build up the lighting on a set, a photographer must realize that most films are not able to record with detail as wide a subject brightness range as the eye can see satisfactorily. This means that your lighting must be so balanced that shadows are less deep than appears perfect to the eye.

This is less of a problem for me than for many other photographers. That's because I use inherently soft lighting most of the time and I like the shadows that I do generate to be fairly dark. Whenever you want to record detail from the brightest highlights to the deepest shadows, you may want to use an exposure meter to ensure that the subject brightness range is within the capabilities of the film type you're using.

DISADVANTAGES

With the exception of quartz-halogen lamps, which perform consistently throughout their life, tungsten lamps gradually lose in light output and give a more reddish light as they age. This can lead to exposure and color-balance inconsistencies.

When a regular tungsten lamp reaches a certain age—before it burns out totally—it's wise to change it. The cost is normally more than made up in less film and time wastage due to inconsistent results.

The heat generated by tungsten lights can cause discomfort. As I've already said, it can also cause subjects such as food and flowers to spoil rapidly. In addition, you should be aware of the danger of hot lamps. Keep all flammable materials away from lamps. This includes drapes, background materials and diffusers. Also, be sure people—especially children—are not in danger of coming in contact with burning lamps.

LIGHT MODIFIERS

A basic light source consist of a bare bulb or tube. The light from a basic source can be modified by the use of reflectors or diffusers.

REFLECTORS

A reflector behind a light source performs two major functions. First, it makes the light more efficient because it catches light and redirects it toward the subject. Without the reflector, much of the useful light coming from the source would be wasted. Second, a reflector gives you control over the illumination. Depending on their design, reflectors can project anything from a narrow to a wide beam of light. Also, at a given subject distance, a large reflector will give a softer light than a small reflector.

With electronic flash, I can control the brightness of the light at the subject position without changing light-to-subject distance. I do it by adjusting the power setting of the unit. This does not affect the color balance of the light. If I were to adjust a tungsten lamp's power output, the color of the light would change.

A wide variety of reflectors is available for electronic flash and tungsten lights.

Reflector Attachments—There are additional light modifiers which, when attached to a light source, give very precise control of the spread of a light beam. Such modifiers include barn doors. They are four hinged, opaque flaps which can be adjusted individually. They enable you to narrow the light beam in one direction more than in another.

Cones and snoots usually narrow a beam symmetrically, generally to produce a circular patch of light. With some snoots, the light is directed through a honeycomb pattern. This gives a smoother gradation to the light beam, with less abrupt falloff at the edges.

Focusing spotlights achieve a similar effect to that provided by a snoot. You focus the light beam through a lens to get the beam spread you want.

I often need to modify the spread of the light in a way that can't be achieved with commercially available devices such as snoots and cones. In such cases I make my own attachments from cardboard or some other suitable material.

DIFFUSERS

The light that is housed in a large reflector can be softened further by the placement of a white, translucent screen in front of the reflector. Such a diffuser spreads the light more uniformly over the reflector's area. Without a diffuser, most reflectors give light with more or less of a hot spot from the central area. In effect, this gives you a small light source that produces contrasty light, superimposed on a large source that produces soft light.

REFLECTOR CARDS

Reflector cards are not attached to a light source but serve as a separate source. Most often, reflector cards redirect light from the main source into shadow areas to brighten them.

Reflector cards need not necessarily be made of cardboard. I call them "cards," simply to distinguish them from reflectors placed on light sources. The "cards" I'm discussing here can also be sheets or metallic reflectors with a variety of surfaces, to give specular or diffuse reflections.

screen on the front. I have numerous Chimera softboxes, ranging from about six inches to about six feet in width.

In the next essay, as well as with several of the photos in the portfolio section, I explain how I get a wide range of light control with my softboxes.

LIGHT SUPPORTS

Electronic-flash manufacturers provide light stands with their equipment. For easy movement, I have mounted my flash power units on wheeled trolleys. A large, sturdy boom stand supports any one of my several softboxes. In addition I have several stands and clamps suitable for holding reflectors, small lamps or small backgrounds in place. Tungsten lights can be mounted on a variety of adjustable stands of different maximum heights.

Many photographers find ceiling rigs for their lights useful. Such rigs have the advantage of keeping lights and cables out of your way while you're working. For my own purposes, I don't find ceiling rigs necessary and believe they can limit the scope of precise light placement.

The most important light source in my studio work is the softbox. I have softboxes ranging from about six inches to about six feet in width. With them, I can create a wide range of lighting effects.

I use large diffusion materials ranging from shower curtains to parachute material and 1/8-inch-thick plexiglass. For proper color balance in your photos, it's important that the diffusing material be white.

UMBRELLAS

Probably the most commonly used reflector on electronic flash is the umbrella. Umbrellas are large reflectors—sometimes as much as six feet in diameter—that give a soft, uniform light. In a sense, umbrellas are at one and the same time reflectors and diffusers.

Because many of my subjects have reflective surfaces, I generally avoid using umbrellas. I don't like to see the blatant reflection of an umbrella in a subject. The reflection from a large *softbox*—a light bank discussed a little later—is much less distracting and more pleasing. However, I sometimes find umbrellas useful for background illumination.

Sometimes a specular reflector is used as main light source. For example, a flash may be used as rim light from behind a subject. The same flash is reflected onto the subject from the front to provide the main illumination.

Reflector cards of different types and shapes play an important part in my photography, as you can see from many of the photos in the portfolio section of this book.

Sometimes, a reflector card just a few inches long does the required job. My largest cards measure 8x8 feet. I have two of these. They are white on one side and black on the other. The black sides are useful for removing light from a subject. This is often necessary to enhance the modeling effect.

SOFTBOX

The most important light source in my studio work is the softbox. This is a large box, painted white on the inside, containing one or more flash heads, and having a translucent diffusing

CONCLUSION

With the basic equipment described in this essay you can achieve most of the lighting effects discussed in the next essay. However, at times I'll introduce lighting, reflectors and other devices for achieving special effects that I have not mentioned yet.

With the proper use of lights, reflectors, reflector cards, diffusers, barn doors, softboxes and other tools, you can achieve remarkable control of your illumination. I'll now describe professional lighting techniques and tell you how I use my lighting system for effective control in a variety of circumstances. □

LIGHTING TECHNIQUE AND CONTROL

Photography, like vision, is not possible without light. What an object looks like depends largely on the way in which light is affected when it strikes the various surfaces, textures and colors of that object.

A creative photographer can emphasize or subdue specific characteristics of a subject. For example, with the skillful use of light, the transparency and delicacy of glass can be emphasized or the high reflectivity of silverware subdued.

ANGLE OF INCIDENCE EQUALS ANGLE OF REFLECTION

The most basic law relating to the behavior of light states that "the angle of incidence equals the angle of reflection." At its most basic, this means that a beam of light that is directed at a flat surface will leave that surface at an angle equal to the angle at which the light strikes the surface (Illustration 1).

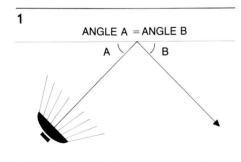

1

ANGLE A = ANGLE B

The law applies equally to curved surfaces. The angle of reflection will equal the angle of incidence at the point where the reflection takes place.

If you remember this basic concept, it will help you to detect how any

specific scene or subject was lit. More important, it will give you greater control of your own photographic lighting.

DAYLIGHT IS THE KEY TO STUDIO LIGHTING

Even though I rarely work with daylight, I never allow myself to forget that the basics of studio lighting are derived from natural daylight.

The key light that makes our world visible is the sun. It is always overhead, usually at an angle that is more or less oblique. Studio lighting is similar. Rarely does the key light come from an angle lower than the horizontal.

Sunlight can be direct and harsh, causing hard shadows. It can be softened by a slight overcast, making shadows relatively soft and light. A heavy overcast tends to produce lighting that is almost shadowless. The same effects can be achieved in the studio by placing diffusing materials in front of a light source.

Beaches, snow scenes and bright walls act as reflectors. They bounce sunlight into shadow areas, thereby softening the scene and the resulting photographic image. Reflectors are used in a studio to achieve basically the same effect.

Soft daylight, entering through a window, provides flattering illumination for many indoor situations. I can easily simulate such light by using a large softbox.

As most studio lighting, the softbox has a distinct advantage over daylight:

It is controllable. Daylight changes constantly in contrast, brightness and color, depending on the weather conditions and the time of day. Studio light is repeatable at will.

HOW TO CONTROL LIGHT

The way in which a light source affects a subject can be controlled in several ways. By using these controls appropriately, you can achieve effective studio lighting for virtually any kind of subject.

DIRECTION

The direction from which a light strikes a subject has perhaps the most significant effect on how a subject looks. We normally think of objects as being opaque. Light simply bounces off such objects according to the law that states that the angle of incidence equals the angle of reflection.

However, many objects are translucent or transparent, or at least have parts that are. With such objects, we have to consider not only the reflection of light, but its partial or total transmission. In determining the best light direction for photography of a specific subject, we must consider *all* the characteristics of the subject.

Front Light—Light from the front, or from near the camera position, tends to give a flat, relatively shadow-free result. Such light is effective in emphasizing the outline and detail of a subject. However, it will do little to bring out the form or shape of an ob-

ject, nor will it show texture in detail.

Side Light—When the light shines at the subject from an angle to the right or left of the camera, shape and texture will become more evident. Shadow areas will be larger and more eye-catching. When side light glances along a surface from the side or the back, texture will be shown to its fullest extent.

Back Light—As you'll see a little later in the text, and also in some of the photos in the portfolio section of this book, one of my favorite types of lighting is soft back light. It is wonderful for bringing out the shape of a subject—be it a couple of simple peppers or an expensive automobile.

As a matter of fact, automobiles are generally photographed outdoors under just such lighting conditions. The time is generally just before sunrise or just after sunset. The soft light from the rear beautifully outlines the car. The remainder of the sky is sufficiently bright to fill shadows without "killing" them.

This is a typical example of using an inherently soft light and yet creating a reasonably contrasty effect. I do the same in my studio with my Chimera softboxes, as you'll see a little later in this essay. I can control the extent of the contrast by the use of reflectors in front of the subject.

A directional back light, shining toward the camera from behind or to the side of the subject, is generally called a *rim light*. It can produce an attractive outline of light on a subject, giving it a convincing three-dimensional look. Because the light shines in the direction of the camera, care must be taken to shield the lens from direct rays from the light to prevent lens flare.

Top Light and Bottom Light—I rarely use lighting that comes from either of these directions. Top light tends to produce unflattering shadows on most subjects—although there are exceptions. Bottom light can be useful for making a transilluminated base for a subject. The base I normally use for this purpose is a sheet of opal plexiglass. This kind of lighting is useful for delicate glass objects.

BRIGHTNESS

The brightness of light on a subject basically affects exposure only. The brighter the light, the less exposure is needed, and vice versa. However, if you control light brightness by adjusting light-to-subject distance, other factors come into play. Most significantly, light distance affects light contrast, as I'll explain next.

CONTRAST

Making a light "soft" by simply putting a diffuser over the source has only a limited effect. Light *distance* from the subject has a much more marked effect. Light-to-subject distance can control two basic kinds of contrast.

Lighting Contrast—The real factor that determines the hardness of a light is the apparent size of the source. I say the *apparent* size of the source because I'm referring to the size of the source as seen from the subject position.

For example, the sun is a light source much larger than our earth and yet we regard it as a hard point source of light. That's because, in view of its great distance from earth, the sun appears small. At the other extreme, a table lamp with a reflector of only eight inches diameter is a relatively large source to a subject a mere foot or two away.

When you move a light source toward a subject, you make the source *relatively* larger from the subject's viewpoint. As a result the light will be softer: The shadow outlines will have a softer, more gentle gradation (Illustration 2).

It's important not to confuse light *brightness* with light *contrast*. Bringing a light closer makes it brighter on the subject but less contrasty. Moving the source farther away makes the light less bright on the subject but more contrasty.

Subject Contrast—The second type of contrast is dependent on the light falloff on the subject. For example, suppose the nearest part of a subject is three feet from the farthest part. If a light source is three feet from the nearest part of the subject, the farthest part will receive about one-fourth of the light of the nearest part.

If the light is moved farther away, to nine feet from the front of the subject, the rear part will receive a little more

2

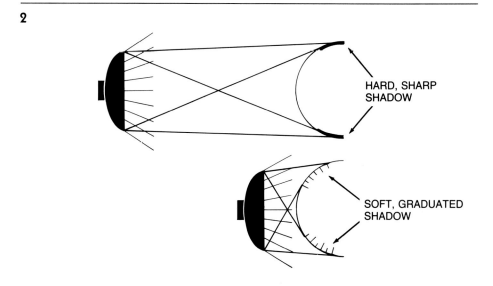

HARD, SHARP SHADOW

SOFT, GRADUATED SHADOW

than half the light received by the front part. The farther you move the light from the subject, the less noticeable will be the difference of brightness between front and rear part of the subject (Illustration 3). Thus, the lower will be the subject contrast as caused by the illumination.

In a sense, you gain one kind of contrast by moving the light *away* and another by moving the light *forward.* Which way you move the light ultimately depends on the effect you're trying to achieve.

Of course, the contrast that's dependent on light falloff on the subject from front to back is significant only if the subject is relatively deep in comparison to the light distance in the first place.

COLOR

Color slide films are balanced for use with light sources having specific color characteristics. For example, daylight-balanced films should be used in average daylight or with electronic flash. With other light sources, corrective filtration will be required to get accurate color rendition.

The most convenient and controllable way to achieve creative color effects is to use color filters. To shift the color balance of the image, use the film intended for the lighting you're using and then apply color compensating (CC) filters or light balancing filters in the series 82 (bluish) and 81 (amber). For dramatic color changes, you can use deep orange, blue, green or red filters.

BASIC LIGHT SETUP

The classic lights in a studio setup, whether for portraits, industrial photography or still-life photography, are *main light, fill light, rim light* and *background light.* As I go on, you'll notice that I rarely use these lights in the conventional way. However, because my lighting technique is aimed to achieve the same basic effects, although in a different manner, it's important to explain them briefly.

Main Light—Also called the *key light,* the main light establishes the shadows and provides the modeling of the subject. My main light often comes from the rear, giving strong form to a subject and hiding flaws. Sometimes it even comes from below, through a translucent base.

Fill Light—Conventionally, the fill light serves to lighten shadows so that the film can record the whole tonal range of the subject for optimum quality and detail. As you'll see later, the inherently soft lighting I normally use rarely calls for a fill light. When shadows need to be lightened, I usually do it with reflector cards.

There's a great advantage in using reflector cards: The light reflected from them is never stronger than, or as strong as, the main light. This means there's no danger of the fill light inadvertently creating secondary shadows that would compete with those produced by the main light.

Rim Light—It provides rim lighting or an edge light to the subject. It's important that the background behind rim-lit areas is dark enough that the rim doesn't merge with the background to form an unrecognizable subject outline.

Background Light—A background can be lit by reflected or transmitted light. The background need not be lit evenly. When a subject has dark and light outlines, illuminate the background so there's always an adequate tonal separation between subject and background. Place light subject areas against a darker background and dark subject parts against a lighter background.

As you'll see a little later, in my photography, the background often consists of part of the main-light source.

MY KIND OF LIGHTING

Like other photographers, I use a wide range of lighting equipment in a fairly conventional way. However, for much of my work I have developed my own lighting technique. It requires remarkably simple equipment but can achieve a very wide range of effects. Here are the basic components that make up my basic lighting arsenal:

SOFTBOX

In much of my photography, the

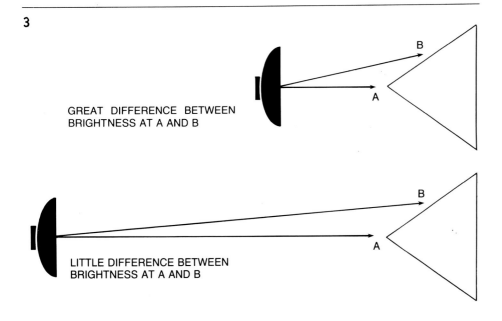

3

GREAT DIFFERENCE BETWEEN BRIGHTNESS AT A AND B

LITTLE DIFFERENCE BETWEEN BRIGHTNESS AT A AND B

only light source I use is a softbox. In its functions as main light, I can control the light contrast in three ways. First, I can do it by selecting a smaller or larger softbox (Illustration 4), or placing it farther from or nearer to the subject, as described earlier. To ensure uniformly soft light, a large softbox generally contains more than one flash head or a light baffle to spread the light.

Second, I can place one of the flash heads inside the softbox closer or farther from the diffusing surface at the front of the box. The farther a lamp is from the diffusing surface, the less noticeable will its individual effect be. When a lamp is almost touching the diffusing surface, I have two kinds of illumination superimposed on each other: A uniformly diffused light and a soft but distinct small source. As the light is moved away from the diffusing surface, it becomes less distinct as a separate source, leaving only a uniformly diffuse light. (Illustration 5.)

The above can be compared to an overcast sky. When the sky is heavily overcast, you don't see the sun and have a uniformly soft light. When the overcast is light, you can see the sun through the cloud layer. Then, you have a uniformly soft light plus the distinctly directional, although soft, light of the sun itself.

Third, I can move the light to the side, away from the lens axis.

Versatility—When you look at the portfolio section of this book, you'll realize what a wide range of lighting effects I can achieve with basic softbox lighting. This simple piece of equipment is remarkably versatile.

The adjustment of the lamp distance in the softbox is very effective in the photography of many kinds of subjects. By placing flash heads well back in the box, I get a uniformly soft light and accordingly large and soft highlights in my subjects. When I bring one flash head well forward toward the diffusing surface, I get a uniformly soft light plus a slightly specular light. This

4

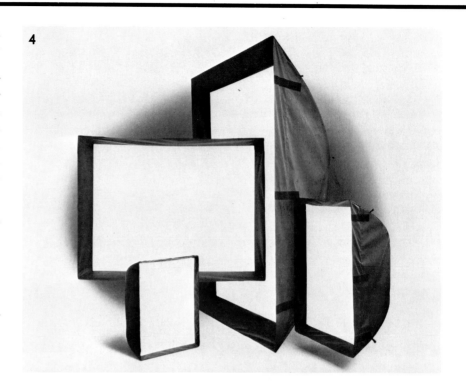

5

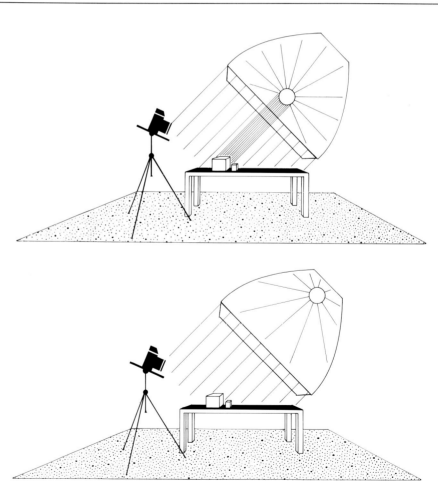

gives me large, soft highlights plus smaller, softly specular highlights that add extra sparkle to an image.

To achieve one of my favorite lighting effects, I position the softbox behind the subject. By tilting the softbox and moving it forward over the subject, I can control the shadows formed at the front of the subject. In effect, the softbox also acts as its own fill light.

The softbox often forms the background for my subject. When it's desirable, I can make part of the background dark by shielding some of the softbox light with a black or gray card.

From my description of the use of a softbox, you can see that this single light source can play the part of many lights. It can be soft main light, together with a slightly directional second main light. It can be the background illumination and the fill light.

REFLECTORS

Reflectors—or reflector cards, as I called them earlier—are effective, easily portable and low-cost secondary light sources. I regard them as an essential extension of my lighting arsenal. Although I occasionally use spotlights and other additional lights for special effects, most of the time all I need in addition to my softbox is a selection of reflectors.

I use mat, white reflector cards of various sizes to fill or brighten shadows. When I use a softbox behind a subject, I often do so to create modeling and drama by having shadows on the front of the subject. To best retain these shadows, I place fill reflectors to the side rather than the front of the subject.

I also use foil reflectors—both silver and gold—for more dramatic re-

flected lighting and for the most efficient use of reflected light. Occasionally, I'll use a small hand mirror to redirect light precisely into a small subject area.

To make transparent liquids sparkle, especially when photographing them against a dark background, I often conceal a small foil reflector behind the bottle or glass containing the liquid.

With a little imagination, you can use simple reflector cards to achieve a wide variety of effects. For example, I have made photos in which I wanted to give the impression that the shots were made indoors by tungsten light but that the subject was also affected by daylight from a window. I simply placed a reddish reflector on one side of the subject and a bluish one on the other.

OTHER ACCESSORIES

Other simple devices that play an important part in my lighting include the following:

Gobos—A gobo—the name is derived from the words "go between"—is a black card that's used to block light (Illustration 6). I can use it to cast a shadow on a background, to hold light back from any specific part of a subject, or to shield the camera lens. It is also useful for shielding part of a softbox to make it an effectively smaller light source and thus produce a relatively more contrasty light.

Scrims—A scrim is a translucent diffusing material that's placed in front of a light source to soften the light. Of course, I don't need scrims on my softboxes. However, when I use other types of lighting I find a scrim very helpful in controlling light contrast.

By placing the light closer or farther from the scrim, I can control the lighting contrast in the same manner I've described for the softbox.

Cookies—A cookie is a card from which specific shapes have been cut out. It is used for the projection of various patterns onto a background (Illustration 7). You can easily cut out

6

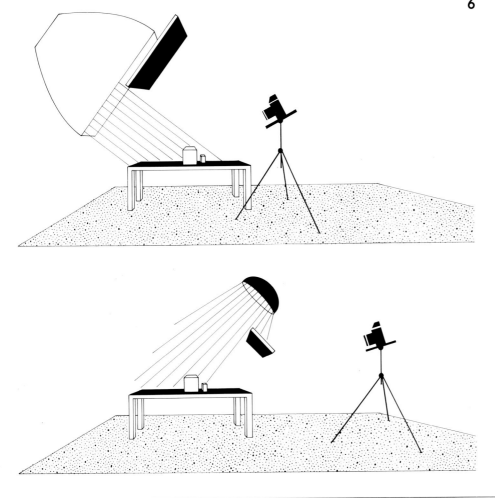

your own cookie cards to suit your particular needs.

SPECIFIC LIGHTING SITUATIONS

To make fine photographs, you must tailor your lighting to the subject being photographed and with the effect you want to achieve in mind. Following are some useful tips on specific lighting situations.

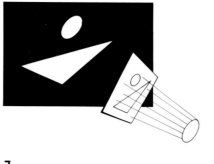

7

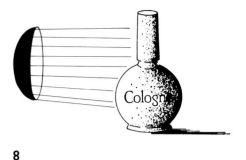

8

HIGH KEY

A high-key picture is one in which most of the image lies at the light end of the tonal scale. High-key images convey a sense of softness, lightness, femininity and cheerfulness. The high-key technique should be used in that context.

High-key lighting is soft and all-encompassing. Typically, you can achieve it with a large softbox in front of the subject and white reflectors at the sides.

High-key photography is not only a matter of lighting. The subject has to be suitable. The ideal subject for a high-key shot is predominantly light. The background should also be light. If dark areas are present in the subject, they should be small. They may be the eyes or lips of a person or perhaps small shadow areas.

LOW KEY

A low-key photograph is one in which most of the subject is at the dark end of tonal scale. Most image parts should be dark gray to black, with only small light areas.

Lighting plays a more important part in low-key photography than do the subject tones. Back or side lighting is often most effective. However, it's best to have a dark subject. For example, dark clothing will make low-key lighting much easier than will relatively bright clothing.

Low-key photos convey a feeling of somberness, moodiness, heaviness and masculinity. The technique should be reserved for appropriate subjects.

LIGHTING OPAQUE OBJECTS

The only way light interplays with opaque objects is by reflection. In choosing and placing your lights, remember that the angle of reflection equals the angle of incidence.

Observe the subject carefully and determine which features you want to emphasize and which you want to subdue. For example, when I photograph a watch, I want to show its face clearly. When I shoot a bottle, the label is probably of prime importance. I can control the emphasis of specific features in an image by using lighting thoughtfully.

Here's a typical example: Because we're accustomed to reading from left to right, a label is more easily read when its left side is lighter than the right side. Therefore, I generally make a point of lighting a label from the left, so its right side gradually falls into shadow (Illustration 8).

If part of a subject is irrelevant or not particularly attractive, hide it in a deep shadow. It's a perfectly permissible part of creative lighting technique. With textured surfaces, decide whether the texture is advantageous or detrimental to the appearance of the subject and then light it to either bring out or suppress the texture.

TRANSPARENT AND TRANSLUCENT OBJECTS

When light can pass through an object, light it in a way that emphasizes that feature. This means putting light *through* the subject rather than *onto* it.

I photograph a lot of glassware. The key light is generally behind the subject and shining through it. A white or black card—depending on the tone of the background—on each side of a glass or bottle provide a graphic outline to the vessel. If a glass object is textured, or has a label on it, I'll add a side light.

When I'm photographing a glass or bottle containing a transparent liquid, I'll often place a small foil reflector behind the vessel to brighten the liquid. This is particularly important when the general background is dark.

Sometimes I'll enhance the appearance of a colorful liquid by watering it down. For example, a red wine may look wonderfully bright and colorful to the eye but lack adequate transparency to yield a sparkling photo. Adding water to the wine may not do much for its taste, but it can certainly make it look much more appetizing in a color photograph!

LIGHTING SHINY OBJECTS

Some objects, such as silverware, are shiny virtually allover. When such objects are rounded or many-sided, they cause a lot of reflections. Such reflections can be light or dark, depending on the tone of the objects in the immediate environment.

There are two basic ways of reducing or removing specular reflections.

9

One is the use of a dulling spray on the subject. A preferred way is the use of appropriate lighting.

To avoid the reflection of surrounding objects, the subject to be photographed must be enveloped by a clean reflecting surface. A light tent is such a surface. It is a cone of translucent, white material, lit evenly from the outside (Illustration 9). The subject is placed in the tent. A small hole is cut in the tent to allow the camera lens to peek through.

Often, shiny objects don't require a total tent. I photograph a lot of silverware, objects with chrome, and other shiny objects, using a large softbox. By observing the object from the camera position, I can determine where additional white reflectors may be needed.

Sometimes it's most effective to have some carefully located dark areas reflected from shiny objects. I achieve these by the careful placement of small black cards. If I were to use a dulling spray on the objects, I would not be able to introduce such dark areas.

Dulling sprays also tend to change the surface characteristics of objects. For example, they make chrome look like a satin or stainless finish.

GETTING A SHADOWLESS BASE

I like shadows and rarely produce a photo in which I deliberately avoid all shadows. However, sometimes shadowless photos are desired—either by an art director or a photographer.

Plexiglass and other translucent plastic materials are excellent bases for shadow-free lighting. Generally, the base doesn't even need to be transilluminated for effective shadow elimination.

USING A LIGHT SWEEP

I have made myself what I call a "light sweep." It is a flexible sheet of milky plexiglass, eight feet long, four feet wide and 1/8-inch thick.

I bent this sweep in such a way that the subject stands on a horizontal surface while the light is passed through a raised section of the sweep.

By placing a flash head higher or lower behind the raised plexiglass, and by adjusting the distance of the flash head from the plexiglass, I can achieve a variety of lighting effects (Illustration 10).

CONCLUSION

I've given you a basic overview of studio lighting and of my personal lighting techniques. You'll find much more information with each of the photos in the portfolio section of this book.

Basically, I don't believe in rules for photographic lighting. There are simply too many variables and exceptions. My best advice is that you should look at all subjects carefully to determine their innate characteristics—be they sturdiness, delicacy, transparency, beautiful shape or exquisite texture. Then, light each subject accordingly.

My final word of advice on lighting would be "Keep It Simple." □

10

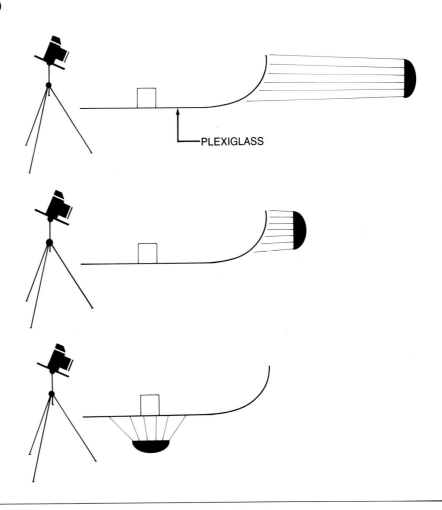

PLEXIGLASS

6
FILM AND ITS USE

Whether a finished photograph is to be in color or b&w, a slide or print, a small or large reproduction, the first step is to record the image on film.

There are many different types of films, made by several manufacturers. In selecting the right film for a specific purpose, you must consider the inherent characteristics of the film. When a film has been selected, both the lighting and the exposure must be tailored to suit that film.

FILM TYPES AND CHARACTERISTICS

The most basic choice a photographer must make in film selection is whether his photos are to be in color or b&w. For me, that decision is generally made by the client.

Film Speed—Each film, whether color or b&w, has a specific speed or sensitivity to light. Fast films need less exposure than slow films. Fast films are useful in dim light. Because I have total control of my lighting in my studio, I rarely need a fast film.

Slow films, both color and b&w, have a distinct advantage over fast films. They have finer grain and therefore give a more homogeneous or smooth-looking image. Slow films also give a sharper image than fast films.

Contrast—Slow color films have higher contrast and generally give richer, more saturated colors than fast films. Slow b&w films also have higher contrast than fast ones. However, the contrast of b&w films can be controlled to some extent at the development stage. Increasing exposure and decreasing development time or developer concentration gives a softer image. Conversely, you get a more contrasty image by decreasing exposure and increasing development.

Slide or Print—When you're shooting in color, you can use either negative or positive film. Color negative films, also called color print films, must be printed or enlarged to produce the final, positive image. Positive films, also called slide or transparency films, give a positive, transparent image, suitable for projection.

Color slide film is most frequently used for reproduction in books, magazines and advertisements. For that reason, I use slide film almost exclusively.

Color slide films are balanced for specific light sources. Daylight-balanced films are intended for use in daylight and with electronic flash. Tungsten-balanced films are for use with tungsten light.

35mm Quality—My favorite films are 35mm Kodachrome 25 and Kodachrome 64. These films give me a sharper and more colorful image than I can get with Ektachrome 64 film in the 2-1/4-inch-square format. This evaluation is based on both formats being enlarged to approximately the same size.

Together with the excellent lenses available for today's SLR cameras, 35mm Kodachrome is good enough for virtually any assignment I may take on. I use the larger formats only to satisfy clients' requests for the larger image, to have access to camera swings and tilts, or when I know a photo is to be retouched.

Retouching—When I know that retouching will be necessary on the original transparency, I shoot on 8x10 film. When smaller-format images need retouching, I have 8x10 duplicate transparencies made first. These are then retouched. Some clients or retouchers prefer to work with color prints. In such cases, I have 11x14 or larger prints made from my slides.

EXPOSURE CONTROL

Correct exposure is dependent on several factors, including the speed of the film, the subject brightness, the kind of image you want to produce and, to some extent, subject contrast.

Exposure for negative films—b&w or color—should normally be based on shadow areas. To yield a good print or enlargement, a negative must have adequate detail in the shadows. Color slide films should be exposed for bright areas. It's most important to have good color in those image parts, even if shadows go black. If you were to expose a slide film for shadow detail, highlight areas would tend to burn out and appear colorless.

For high-quality color slides, the subject should have a brightness range no wider than the film can record satisfactorily. The subject brightness range should be no wider than about 32:1. This means that the brightest subject parts should reflect no more than 32 times the light reflected from the darkest parts.

Subject brightness is dependent on two factors—the reflectivity of a subject area and the brightness of the light striking that part.

Exposure Assessment—Because I work in a controlled studio environment in which I am very familiar with the lighting I use, I rarely use an exposure meter. However, I always make Polaroid instant test prints. They serve several purposes: They give me an indication of lighting, exposure, as well

as composition. They also provide me with something concrete to show to a client. By discussing a Polaroid print with a client, I can be more certain of getting precisely what is needed in the final shot.

Just as you must interpret the *light* reading given by a meter into an effective camera *exposure*, so you must also evaluate Polaroid test prints. Polaroid color films are generally more contrasty than conventional slide films. Thus, if lighting is satisfactory for Kodachrome or Ektachrome film, I must expect a Polaroid print that's excessively contrasty.

If you want to make Polaroid test prints with a conventional camera, you need a special Polaroid film back. Such backs are available for several cameras, including Nikon SLRs, Hasselblads, 4x5 and 8x10 cameras.

I rarely need to worry about remaining within the subject brightness range the film can accept. That's because usually my lighting is inherently soft. Sometimes I create deep shadows deliberately. When I do, I don't usually object to losing detail in those areas.

When I have determined what I consider optimum exposure, I'll usually bracket my exposures 1/2 and 1 exposure step on either side of that optimum. For example, if optimum exposure with electronic flash seems to be *f*-11, I'll make additional exposures at half-step intervals from *f*-8 to *f*-16.

A few words of advice to users of exposure meters: If you use a reflected-light meter, be sure to read only the area you're interested in, without the intrusion of misleading brighter or darker areas. Also, make the reading in the actual shooting conditions. Be careful not to cast a shadow on the subject as you're making the reading. Then, translate the *light* reading into a suitable *exposure*.

A light meter is designed to indicate correct exposure of an average subject—one that reflects about 18% of the light striking it. Because a meter doesn't "know" what it's being pointed at, it "assumes" that everything is an average, 18% gray. For example, if you take a reading of a nearly white surface and expose according to a meter, the end result will be a dull-gray image. To reproduce the tone of the subject faithfully, you need to give considerably more exposure than the meter indicated. You'll need to increase the indicated exposure by about 2 to 2-1/2 steps.

If you're using an incident-light meter, hold the meter as close to the subject as possible. Remember, subject brightness is dependent not only on the brightness of the illumination but also on the distance of the light source from the subject.

FILM PROCESSING

It's relatively easy to process b&w film and make prints or enlargements in your own darkroom. As indicated earlier, you can control image contrast, not just by the film you select but by the way you develop it. You have further control over the printed image by choosing paper of a specific contrast and by giving selectively more or less exposure to different image parts. By *dodging*, you hold back light from an image area to get a lighter image in that part of the print. By *burning in*, you give an image part additional light, causing the print image there to be darker.

Color negative film processing is also relatively easy, although you don't have the contrast control you have with b&w film.

Slide-film processing requires more elaborate equipment, more precise temperature control and involves more steps. I wouldn't advise you to do your own slide-film processing unless you're going to shoot a lot of film on a regular basis. I have all my slide film processed by a commercial lab. In Los Angeles, I get my processed slides back within about two hours. Similar fast service is available in other cities.

You have very limited control of image contrast at the processing stage with slide film. This means it's more important to light the subject appropriately when you shoot it. If necessary, you may also have to select the subject tones carefully to keep within the subject brightness range the film is able to accept. Because the brightness range acceptable to slide film is relatively narrow, my inherently soft lighting is usually ideal.

Special Custom Processing— Commercial labs that cater to the professional photographer can modify their Ektachrome processing to suit specific needs. The processing steps for Kodachrome films cannot be manipulated in this manner.

If you know that an Ektachrome film has been underexposed by one

When using a reflected-light meter, read only the area you're interested in. Avoid the intrusion of misleading lighter or darker areas. If you're using an incident-light meter, hold the meter at the subject position. Remember, the subject's and meter's distance from the light affects subject brightness and meter reading respectively.

exposure step, you can ask the lab to *push* the film by one step. This additional development will, in effect, double the film's speed. Should you have inadvertently overexposed a film, you can ask the lab to *pull* it. The decrease in development will artificially lower the film's speed, so that the finished slides will have correct tonality.

Severe pushing and pulling have a somewhat detrimental effect on image quality and are not to be recommended unless absolutely necessary. I

wouldn't advise you to request much more change than one exposure step at the processing stage.

Pushing Ektachrome tends to warm the color balance. If you anticipate the need for pushing, you can compensate for the color shift by using bluish filtration. Pulling the film tends to give it a cool, bluish imbalance.

I rarely underexpose or overexpose

tion is not precisely correct for the film you're using, you can use filters to fine tune color. Because I use electronic flash for most of my work, I have little need for filtration. My use of filters is limited to fine tuning the color balance of a specific film batch, when necessary, and for achieving special creative effects.

I have a full set of color-

Occasionally, I'll use a polarizing filter to reduce reflections. For example, if I want to show a series of dials under a glass plate on a piece of electronic equipment, I may use a polarizer to reduce surface reflections to an acceptable extent. Only rarely will I totally eliminate a reflection.

Neutral-density filters reduce light transmission without affecting color balance. They are useful when I make test exposures on Polaroid film. For example, I may test on a 400-speed Polaroid film and then shoot the final image on 64-speed Ektachrome. To keep the exposure settings the same, I must reduce the light to the film by a factor of about 6 when shooting on the Polaroid film. A neutral density filter of density 0.8 reduces the light transmitted by about the right amount.

With slide film, contrast control at the processing stage is minimal. Therefore, you must light the subject appropriately when you shoot it. If necessary, you may need to select subject tones carefully to stay within the subject brightness range a film can accept. Because the brightness range acceptable to slide film is relatively narrow, my softbox lighting is usually ideal.

film deliberately. However, sometimes, when working under difficult and unusual lighting conditions, I'm not sure whether I am giving optimum exposure. In such cases, I enlist the help of my lab. When using roll film, this is how it works:

I'll ask the lab to snip one or two exposures off the first film and process these sections normally. When I see the results, I decide whether, and by how much, the remaining film needs to be push or pull processed.

A lab can snip 35mm and 120-size roll film. Because you lose one or two exposures at the beginning of a roll when you use this procedure, it's wise to shoot several frames of the same image at that point in the roll.

When I use 4x5 or 8x10 film, I'll shoot several sheets of the same setup and have the lab process one first. On evaluation of the result, I determine what processing adjustment may be necessary.

FILTRATION

If the color balance of the illumina-

compensating (CC) filters and warming and cooling filters in the light-balancing series 81 (amber) and 82 (bluish) respectively. The filters I use most commonly are an 81A and 81B. I use them for enhancing the appearance of human skin tones. They are also useful in making some food items more attractive in a photograph.

To get the best possible color rendition with my studio flash setup, I buy 20 or more 36-exposure films having the same manufacturer's batch number at a time. I use one of these films for making color tests, using several CC filters. If, for example, a CC10R filter gives the best color balance, I'll use that filter for the entire batch. Any *creative* filtration I want to use is added to that base filter.

On my 35mm and 2-1/4-inch-square cameras, I mount filters on the lens front. When using a 4x5 and 8x10 camera, I attach filters to the back of the lens, inside the camera. This keeps the filters out of the way of the lens controls and also minimizes possible flare.

Sometimes, when I want to record a background out of focus, I'll use an ND filter to enable me to shoot at a wide-open lens aperture.

Special-effect filters are available in large varieties. They are designed to give multiple images, superimposed rainbows, different colors in different image parts, starbursts, soft-focus images and many other effects.

I consider most of these filters esthetically undesirable and don't use them. One exception is the starburst filter, which I'll use very rarely. When I want a soft-focus effect, I don't use commercially available filters but make my own. I simply smear a small amount of petroleum jelly on a clear filter and place it in front of the lens. Alternatively, I'll stretch a piece of black nylon—from an old stocking—over the lens.

In addition to regular camera filters, I sometimes use colored gels in front of my lights for special effects. I buy gels in sheets—generally about 2x2 feet—from a theatrical supply house. □

IMAGE CONTROL

In the preceding essays, I told you mostly about facilities, equipment and technique. It's now time to give more thought to the esthetics of studio photography.

You can control an image in many ways. The arrangement of the components that make up the subject, the emphasis or suppression of perspective, the use of color and the choice of background can all have a decisive effect on the final photograph you create.

A painter has the luxury of being able to project a world of fantasy onto his canvas. He can create almost anything his mind is capable of imagining. A photographer must work with the world of reality. Even in the most abstract of photographs, the building blocks ,are real things.

To be creative, a photographer must often manipulate reality. This may involve exaggerating perspective, changing colors by filtration, hiding unwanted detail in deep shadow or eliminating reflections from a highly-reflective subject. But the raw material is always real and concrete.

A skilled photographer can enhance the basic characteristics of a subject. For example, he can emphasize the delicacy of glassware or the texture of cloth and leather with appropriate lighting.

Modern, fully automated cameras have made photography easy. Anyone can take photos that are sharp and well exposed and can do so consistently. As I've said earlier in this book, as a professional photographer, my challenge is not simply to record a subject as it *looks,* but as it really *is.* This means that I must convey to a viewer the feel, look, weight and shape of an object as closely as possible to the way he would experience it from the real thing.

Photography is an art that's based on several technologies. Image control, in its many aspects, is dependent on creative seeing and on the capable use of the photographic craft in all its aspects.

COMPOSITION

The most basic part of image control is composition. This involves the proper placement of the various components of a scene or subject for the best visual result. Composition should ensure that the viewer's eye does not roam from the picture area but that attention is focused on the key part of the subject.

Composition also requires that an image does not appear lopsided. Image parts should be so located that the picture doesn't seem out of balance. There must be a balance, not only of the sizes of image components, but also of their tones and colors. For example, a very dark object will appear to have more visual "weight" than a light object and a deep-red object will seem heavier than a light-pink one. This must be taken into account when an image is composed.

Subject Placement—The key components in a composition are generally most effective when placed in specific locations. Balance is only one aspect that must be considered.

One of the classic rules of composition—for painter and photographer alike—is the *rule of thirds.* It states that the main subject component in a picture should be about one third of the way into the picture area, both horizontally and vertically.

Triangles also play an important part in composition. By placing key subjects in such a way that they form a triangle, a viewer's attention is likely to be stimulated and, at the same time, kept within the picture area.

However useful some "rules" may be, I can't overemphasize that even the best should be regarded as no more than guidelines for a creative photographer. In the portfolio section of this book, you'll see plenty of examples where I break the rule of thirds, and other rules. Do what looks best to you. As long as you have a good reason for what you're doing, you're probably doing the right thing!

Movement from Left to Right— Because, in our culture, we read from left to right, you'll create a sense of movement most effectively from left to right in a photo. For this reason, if I want a viewer to scan subject detail, I'll light the subject from the left side so that the darker areas and shadows are on the right side. The eye is then drawn first to the brighter, left side and easily, naturally scans toward the right. The reverse would be less natural and, therefore, visually less effective.

Keep It Simple—If I were to tell you 50 numbers, you may remember five of them. If I were to tell you five numbers, you would probably remember them all. Apply this thought to your photographic composition. Include only those things that are relevant and effective in telling your story. Eliminate everything else. Less is more!

PERSPECTIVE

Architectural photographers are very conscious of perspective. They decide deliberately whether the ver-

tical lines of a building should converge in a picture or should be corrected to appear parallel, even though the camera may be pointed upwards.

If a building is to appear large and imposing, a photographer is likely to move close and use a wide-angle lens. This viewpoint exaggerates perspective—the apparent size differences caused by differences in distance.

The still-life photographer tends to be much less perspective-conscious, especially if he doesn't use a large-format camera that offers perspective control. That's a pity because, even with a 35mm camera, you have considerable creative control through manipulating perspective.

Exaggerated Perspective—If I want to exaggerate perspective, I shoot at an oblique angle, either vertically or horizontally, come close to the subject, and use a wide-angle lens that includes the entire subject. For example, I may shoot down at a bottle to make its top appear much larger than its base. When I use a large-format camera, I tend to use swings and tilts more frequently to *exaggerate* perspective than to *correct* it.

mula: For shots with depth and perspective, shoot at an angle, move close and use a wide-angle lens. For shots with strong two-dimensional, graphic impact, shoot head-on, place the camera at a greater distance and shoot with a long lens.

Lens and Distance Selection—I'm often asked whether I determine subject distance first and then select the appropriate lens or the other way about. It's a little like the classic question about which came first, the chicken or the egg.

I'll usually begin by placing on the camera the lens I think will be appropriate and then compose the image. If my choice was wrong, I'll change lens and camera position accordingly. So, although I choose lens before camera-to-subject distance, in effect both go so closely hand-in-hand that I can't claim that one comes before the other.

Subject Placement and Perspective—Sometimes the placement of the subject itself can play a decisive part in the perspective effect you create. For example, the key component of a food photo may be a bundle of spaghetti. By placing the strands so they converge toward the distance, I exaggerate per-

proper color balance. However, subject contrast and colors can also play an important creative part in an image.

Tonal contrast plays an important part in my compositions. That may be surprising when you realize that I generally use soft, diffused lighting. However, I frequently use back light and deliberately create strong frontal shadows. These shadows are carefully placed to reinforce a strong composition.

Color contrast is a difficult thing to define. Different people seem to understand different things by it. My own view is that there's contrast between any two things that appear decidedly different. For example, there's contrast between light-gray and black, white and dark-gray, different hues such as blue and red, as well as between saturated colors and pastel colors.

I like color contrast but don't like using clashing colors in my photos. What colors clash? This, as so much about color, is very much a subjective matter. If two colors don't look pleasing together, they clash. Contrasting colors, such as red and blue, or orange and yellow, need not necessarily clash. However, most people would probably dislike a combination of blue and brown or purple and orange.

What Colors Signify—Saturated colors, such as bright red, green and blue tend to be associated with strength and masculinity. These colors are suitable for photos of electronic equipment, machinery and tools, and photos with bold graphics.

Pastel colors, such as pink and light blue, are associated with femininity and lightness. I use these colors in photos featuring such products as perfume and lingerie.

Background Colors—The background plays an important part in a total photographic composition. Its colors must interplay effectively with those of the subject. For strong graphic impact, you can generate color contrast between subject and background.

If I were to tell you 50 numbers, you may remember five of them. If I told you five numbers, you would probably remember them all. Apply this thought to photographic composition. Include only those things that are relevant and effective in telling your story. Eliminate everything else. Less is more!

Flattened Perspective—In some of my work, I want to reduce the effect of perspective to a minimum to achieve a strong graphic effect. I use this approach in much of my photography of flowers for posters. To flatten perspective, I shoot the subject head-on, place the camera a relatively long distance away, and use a long lens that frames the subject as I want it.

My Formula—Here's my basic for-

spective. On the other hand, by making the strands diverge toward the distance I minimize perspective. The same principle can be applied to a variety of subjects that can be positioned at different angles.

COLOR AND CONTRAST

In the previous essay, I discussed contrast as it relates to proper exposure, and color filtration as it relates to

Or, you may want a more gentle, subdued effect by selecting a background color similar to the subject color.

If you want to create the illusion of depth and distance, use a blue background. Perhaps because we associate blue with the sky, a blue background in a photo tends to appear far away. If you want to suggest closeness and intimacy, use a red or orange background. It has the opposite effect of blue.

A neutral gray background is useful when you want to emphasize subject colors and make them stand out.

Monochromatic Images—In many of my images, I like to minimize contrast by using one basic color, together with slight variations. For example, the entire image may consist of subtly different shades of red, orange and brown. You'll see several examples of this kind in the portfolio section of this book.

Monochromatic images can be every bit as eye-catching as images containing several varied colors. However, because of the lack of color contrast, it's wise to boost tonal contrast by using somewhat more contrasty lighting.

BACKGROUNDS

As I indicated a little earlier, the background is an important, integral part of most compositions. I photograph many common, everyday objects in my studio. I can make them look different and exciting by the lighting and composition I use. However, the background can also play a major role in making an outstanding image of a very ordinary-looking object.

I use a wide variety of surfaces as backgrounds. They include Mylar, stainless steel, plexiglass, tiles and Formica. When the background material is translucent, I'll often backlight it. Sometimes, when it's appropriate for the subject, I'll wet the surface. Sometimes I'll use a background material with strong surface texture and crosslight it for maximum effect.

Many of my subjects are basically similar to those photographed by my competitors. One way I can make my work stand out is by using my imagination—and this applies as

Tonal contrast plays an important part in my compositions. That may surprise you because I generally use soft, diffused light. However, I frequently use back lighting and deliberately create strong frontal shadows. I place these shadows carefully to reinforce a good graphic composition.

much to background choice and use as anything else.

PEOPLE IN MY PHOTOS

From time to time, I'll include people in my product photos, either because a client requests it or because I feel it will add impact to the image.

When the key feature of a picture is a product, it's important to avoid making the person featured in the picture dominant. The composition and lighting must always be such that the client's product is the prime point of interest.

Hands—Sometimes I'll include only a model's hands with a product. Truly photogenic hands are remarkably difficult to find. I look for slender fingers that can hold a product without obstructing too much of it. I also insist on well manicured hands with nails that aren't excessively long.

To avoid the unattractive bulge of blood vessels on the back of a hand, I'll sometimes ask a model to hold her hands high above her head for a minute. If I shoot within seconds of her bringing her hands down, I get more attractive, smooth looking hands in the photo.

Especially with male models, I avoid showing bare arms. A hairy expanse of arm reaching into a picture will spoil any image, so I insist on long sleeves.

TYPICAL SUBJECTS

To learn about the way I control the various subject types I photograph, study the text with the photos in the portfolio section. Here, I want to give you a brief overview of some of the problems I commonly face and how I deal with them.

Food—Food photography usually consists more of preparatory work than actual photography. I have a fully-equipped kitchen in my studio. On a food assignment, a professional food stylist will be at work in that kitchen.

Electronic flash has made food photography much easier than it used to be many years ago under hot tungsten lights. Even so, I generally shoot "stand-in" food for testing purposes and then reshoot the "real" food for the final shots. Much food just doesn't look its best for very long.

Various tricks are used to make food look better—even though, at the same time, they may make it totally inedible! Vegetable oils are painted on certain foods to give them an attractive luster. Certain liquids have to be watered down to enable enough light to pass through them. Ice cream can be placed in a Freon tank to freeze it solid and make it survive a shooting session.

Hamburgers are sometimes blow-torched to make them look more appetizing. In addition, they can have grill marks put on them with hot skewers.

Flowers—I frequently photograph flowers and flower arrangements for posters. Most flowers look better to the eye than to the camera. To find truly

photogenic blooms, I have to buy a lot of flowers.

When photographing flowers, I aim for strong graphic impact. This means that lines, shapes and patterns are important. Sometimes it will take hours to complete just one arrangement to my total satisfaction.

To hold flowers firmly in place in a vase, I use a spongy base known as an *oasis*. In a transparent vase, I'll use glass marbles to achieve the same effect.

It's generally known that putting aspirin in the water makes flowers last longer. What is less commonly known is that a few drops of household bleach, such as Clorox, have the same effect.

label that must be legible, additional frontal illumination may be needed.

I've found that rubbing vinegar on glass gives it a beautiful shine that's difficult to get in any other way.

To simulate condensation, such as you would get on a glass of cold beer, mix about one part of glycerin with four parts of water and spray the solution on the glass with a spray can.

Sometimes it's attractive to have a few air bubbles in a liquid. You can inject these with an eye dropper or straw. If you put a few drops of detergent or a wetting agent such as Photo-Flo in the liquid, the bubbles will generally remain longer.

Ice Cubes—Homemade ice cubes generally have a milky center that isn't

best photographed at dawn or dusk, just before the sun rises or just after the sun has set. At those times, the bright sky provides a low, large and soft light source. In the studio, you can simulate such lighting by using a very large bank of diffused light at a low position.

When shooting a car from a high viewpoint, the light should come from the rear. When the camera viewpoint is low, have the light coming from the side.

To fill shadows, you'll need very large reflector cards. They perform the same job in the studio that the remainder of the sky performs in the outdoor setting.

Packaging—I take a lot of photographs for use on packaging for a wide variety of items, ranging from AT&T telephones to Lawry's food products. Such photography must usually fit a precisely prescribed layout.

Each package has a specific shape. The product, also, has its own characteristic shape. The photo must be positioned in a predetermined location on the package, surrounded by product name, logo and, often, instructions for use.

When a person appears in a picture whose key feature is a client's product, it's important to avoid giving the person dominance over the product. Composition and lighting must be such as to make the product the prime point of interest.

If you have some buds that you would like to photograph as open flowers, you can speed up the opening process by placing the stems in comfortably warm water. Generally, you'll have the opened flowers within an hour or so.

Flowers always look good with a few dewdrops on them. To make your "dewdrops" last and not dry up rapidly, mix one part of glycerin with about three parts of water.

Electronic Equipment—I photograph a lot of computer hardware, hi-fi equipment and diverse electronic components. In keeping with the subject matter, I aim for slick, futuristic composition and lighting. I'll use colored lights—particularly red and blue—and create a dramatic effect by using deep shadows and silhouetting areas in which detail is not important.

Glassware—Glass is generally best lit from behind or the side. If the glass is engraved or textured, or if there's a

attractive or photogenic. I buy ice in stores, being very careful to select cubes that are clear throughout. More often, however, I use another alternative—plastic ice cubes. They have the added advantage of never melting.

Jewelry—Because most jewelry is small, the final image is generally a considerable magnification. As you enlarge the image, you also enlarge any fingermarks or dust that may be on the jewelry. Therefore, it's important to be particularly careful regarding cleanliness. I always wear cotton gloves when handling jewelry in the studio.

Much jewelry has highly reflective surfaces. You must determine which reflections are desirable and which should be avoided. Then, position and light the subject accordingly. Sometimes you may need a combination of soft tent lighting and a small spotlight.

Automobiles—Outdoors, cars are

A VALUABLE EXERCISE

I've told you something about the basic tools of image control. Key components are composition, perspective, color, contrast and background. To test your ability at controlling those components to make a variety of photographic images, I suggest you photograph a simple subject—an egg—in a dozen totally different ways.

Vary the lighting to get high-key and low-key effects. Shoot from different angles and distances, using different lenses. Vary the background. Use color filters on the lights or the camera lens. Use different props with the egg, including other eggs. Use broken eggs, whole eggs, cooked eggs and egg shells. □

STARTING A PROFESSIONAL STUDIO

Still-life studio photography fills a basic need in many areas of business and industry. A studio can be as successful in a relatively small town as in a large city. However, while large cities like New York, Chicago and Los Angeles can support specialists, such as food photographers, smaller communities provide the best livelihood for generalists.

Even though my studio is in Los Angeles, and although I am perhaps best known for my food, flower and product photography, I like to take on many varied assignments, as you can see from the portfolio of photos that follows. Even for a specialist, photo assignments of a general nature provide a healthy business base.

ADVICE IS AVAILABLE

Good photographers, like other creative people such as actors and musicians, are often poor business people. They need capable and trustworthy business advisers. Therein seems to lie a Catch-22: You can't employ an adviser until you make enough money to afford one, and you can't make enough money without the help of an adviser.

However, there is help at hand. *Advertising Photographers of America (APA)* is an organization that provides advice on business techniques. APA can also put photographers in touch with lawyers and other photographers.

Sales representatives are also helpful. I employ a rep who finds buyers for my photography. I pay her 25% of the total fee I'm paid. I don't recommend using a rep who sells the work of another photographer who does similar work to yours. My rep represents fashion, architectural and industrial photographers, but no one who works in direct competition with me.

Because of her constant contact with buyers of photography, my rep can often give me useful hints on current needs and markets. My rep is not a financial risk because I pay her only commission on sales and no salary.

LOCATION

Choose your studio location carefully. Because my work is mainly commercial, it's OK to have my studio in an industrial area. If I were in the high-priced portraiture business, I would be better located in a prestigious location in a choice part of town.

Get the best and largest possible space at the lowest available rent. When I selected my studio, I also made sure it was close to good color labs, camera stores and prop houses.

BE FLEXIBLE AND PROGRESSIVE

If you don't want to overextend yourself financially at any time, and yet plan to grow, you'll have to contend with the need to move from time to time, especially in the earlier, developmental years. I've had five different studios in slightly more than ten years. Each move was expensive but proved worthwhile in the end.

Some of my earlier studios were ready to move into, so I had little expenditure in preparing them for my type of work. As my business has grown and my work become more complex, I've needed larger and more complex facilities. I have invested more than $45,000 in additions and modifications to my present studio. However, as I said earlier in this book, by regularly renting out my studio to other photographers, I am able to bear those costs more easily.

I gave you more detailed information about setting up a studio in Essay 2, on page 8.

Whatever you do, keep a close eye on your income and your expenses. Be sure that your studio supports you rather than you supporting an expensive studio.

HOW TO GET STARTED

Begin by getting assignments or doing speculative photography that doesn't require a studio. Start getting together a book, or portfolio, of your best work. Look for models who are beginning in the business, just like you. Many will be delighted to pose for you in return for some photos for their portfolios.

When I need props for a photo session, I can rent them from major stores in Los Angeles at 25% of the purchase price. I'm sure the same can be done in other major cities. In smaller towns, ask store managers whether you can

rent items on the same basis.

I've heard that some photo and art schools even get props by "purchasing" items on a money-back guarantee. When they have finished with the props, they return them to the store and get their money back. I don't recommend this approach. However, it shows that there are ways of getting temporary use of essential items at low or no cost.

The best way to get assignments is to have been published. As soon as you get some of your work published, collect printed specimens, or tear sheets. Include them in your portfolio. My business tripled very soon after I started getting regular editorial exposure and credit in *Home* magazine, the Los Angeles Times Sunday supplement.

Until you can afford to rent a studio, shoot in your house, garage or basement. Always live and operate within your means. You may rent your first real studio space by the hour or day. Such facilities are readily available in most cities. Ask other local photographers for information.

EQUIPMENT

Start with basic equipment: Camera, two or three lenses, electron-

agencies and art directors all over the country. Among them are *The Black Book* and *American Photography Showcase*. Regional books include *The Los Angeles Workbook* and similar books in New York, Chicago and a few other large cities.

These books include listings of photographers' names, addresses and phone numbers and full-page features of photographers' work. The fee to a photographer for a full page in such an annual publication varies from about $6,000 for *The Black Book* to about $1,800 for *The Los Angeles Workbook*. The fee generally includes 1,000 to 2,000 separate tear sheets of your page in the book.

These fees appear high. However, from my own experience, and that of other photographers to whom I've spoken, a full-page feature will generally bring in enough work to make the investment worthwhile. A mere listing of name and location, on the other hand, will generally do almost nothing to promote your business.

Before you can afford the above fees, or if you live in a relatively small community, you can promote your work by periodic mailings to prospective and actual clients. Over a period of time, send out cards showing

or no financial reward with the understanding that you're to be given a prominent credit line.

As soon as you can afford it, have a promotional brochure printed. Leave this with advertising agencies, design studios and potential clients.

PUBLIC DISPLAYS

Because my work is commercial, it doesn't lend itself ideally to exhibition in public buildings and galleries. However, there are businesses, banks, restaurants and public galleries that do show such work from time to time. Find out what the opportunities are in your area. And, when you have your own studio, don't forget an attractive display in your window or reception area.

HOW I PRICE MY PHOTOGRAPHY

I prefer to charge for my work by the shot rather than by the day or hour. It's easier for both me and the client. When a client is paying by the shot, he can be more certain of what the job will actually cost him.

Although I have established a rate structure for my work, I'm pretty flexible with it. If I have a potential client whose financial capabilities are incompatible with my rates, I'll often reduce my price accordingly. I always assume that such a client could eventually become a regular, important customer.

Expenses—In addition to the photography fee, it's customary for photographers to charge for their expenses. I charge for such items as film used, processing costs, props purchased or rented, equipment rentals, and the pay for assistants and messengers.

Anything I purchase and charge to the customer becomes the customer's property. For example, if I buy props, the client is entitled to take them with him.

Sometimes a client asks for a specific color of seamless paper—a color I don't have and would rarely use. I'll

Begin by getting assignments or doing speculative photography that doesn't require a studio. Start assembling a book, or portfolio, of your best work. Look for models who are beginning in the business, just like you. Many will be delighted to pose for you in return for some photos for their portfolios.

ic flash, tripod, filters and exposure meter. Don't purchase items you'll need only rarely, such as long telephoto lenses, fish-eye lenses or a large-format camera. They can easily be rented in most cities.

PROMOTION

There are special promotional books that reach the desks of advertising

different photos you've taken, together with important data about your work and your location.

Promoting yourself means getting your work—and your name—seen as widely as possible. One of the best ways of doing this is by having your photos published with a credit line. To get your work published when you're starting out, offer your photos for little

charge for the purchase of this item. The customer can take it with him when the job is completed although I have never had a client who has taken advantage of this right. When I use seamless paper that I have in stock, I'll charge the customer only for the amount actually used.

Because most expenses involve some labor, such as visits to labs or stores, it's customary to add a markup—usually about 10% to 15%—to expenses charged.

Sell specific Rights—To get the greatest possible financial reward for your photography, it's wise, when possible, to sell specific rights to the client and retain ownership of the photo. However, when you resell a photo that was shot for a client, you must be careful not to create a conflicting situation. For example, I would never sell a photo made for one whiskey manufacturer to another such manufacturer. On the other hand, I would be happy to sell the photo to a women's magazine for use on a general feature on drink.

You should expect payment for your work within 30 days of the billing date and your invoices should clearly state this. After 30 days, at least according to California law, you're entitled to charge interest on the debt. If you haven't been paid after 60 days, call the client and remind him of the outstanding debt. If payment has not been made after 90 days, indicate that you intend to take legal action.

To encourage prompt payment, my bills state clearly that "usage rights are transferred to the client upon completion of payment."

WORKING WITH PEOPLE

You may not see many people in my pictures, but people play a large part in my work. When I'm shooting, I'll generally have the client's representative and an art director with me. Often, there will also be a stylist on hand. Sometimes I need models. On most assignments, I'll have an assistant with me.

It's important to treat people well. Provide a comfortable sitting area for them. Keep them supplied with coffee and other beverages. Take them out to lunch. Impress them with your professionalism, your photographic techniques and your facilities.

In my contacts with other photographers, I've found out that many of them tend to be shy loners. It's important for them to remember that, no matter how hospitable they are to people in the studio, the busy lives of art directors and clients tends to make "out of sight, out of mind" the rule of the day. To keep prospective customers in your mind, keep contact. Deliver jobs personally, make brief phone calls, or suggest an occasional lunch. It's pleasant—and it makes for better business.

BUILDING A SET

I frequently have to construct special sets for photography. I may need anything from a complex living-room background to a fireplace or a simple bookshelf.

When it's a simple project and we have the time, I'll do the job myself or have my assistant do it. When an elaborate construction is needed, I'll hire a set builder. Such specialists are readily available in the Los Angeles area. If you can't find one in your area, get a competent carpenter or cabinetmaker. It's customary to charge the client for the set construction, with the addition of a moderate markup.

CONCLUSION

As I said earlier in this essay, a professional photographer should be flexible and adaptable. Professional photography is a mixture of technology, art and business. This calls for some compromises.

Perhaps the greatest compromise is this: You want to be the best possible artist and yet make a living. This means you must satisfy both yourself and your client. Remember that the client's first aim is to sell a product.

If you can retain both your artistic and professional integrity, you'll be what I always claim I am: an effective visual problem solver. ☐

1

Client: United Silver and Cutlery
Ad Agency: Josh Freeman
Design Office
Art Director: Cheryl Lewin
Camera: Nikon F2
Lens: 50mm macro
Lighting: One 2000-watt-second
electronic flash in 4x4-foot
Chimera softbox
Film: Kodachrome 25
Exposure: Between *f*-22 and *f*-32

This photo was taken for reproduction on packaging for silverware. Because the packaging would be used for a variety of items, it was important to make an image that symbolized silverware in general rather than one that showed any particular spoon, fork or knife in detail.

Nothing symbolizes silverware more strongly than the tines of a fork. I felt that I could keep the symbolism strong by shooting a two dimensional and symmetrical graphic representation of the fork.

I placed a 4x4-foot softbox near the camera to achieve the clean, silvery appearance of the fork. When the fork faced the camera squarely, the camera was reflected in the fork. To avoid this, I turned the fork just far enough to lose the reflection but not so far as to destroy the symmetry of the image.

To add a little extra life—and perhaps humor—we carefully placed a small piece of lettuce on the fork. It also added color to an otherwise colorless image.

The black background, consisting of a black velvet cloth about four feet behind the fork, made the fork stand out dramatically. □

Purpose: Photo for my portfolio
Camera: Nikon F2
Lens: 500mm
Lighting: One 2000-watt-second electronic flash in a 6x18-inch strip light
Film: Kodachrome 25
Filtration: Nylon diffuser on lens
Exposure: *f*-16

The subject matter—milk, eggs and dark background—was basically black and white, with almost no color. However, I made the shot on color film anyway. It shows how effective even subtle colors can be. The milk and eggs look much more realistic with just a touch of warm color in them than they would on b&w film.

To create a graphic, two-dimensional effect, I shot from about 40 feet away, using a 500mm lens on my Nikon. To further minimize perspective, I aimed the camera horizontally.

The main light was to the left of the camera. I used a special 6x18-inch strip light to create the attractive vertical reflections on bottle and glass. An 8x10-inch white reflector card on the right side of the subject added some detail to the shadow side and provided a nice, white rim to the right side of the glass.

I wanted to soften the image a little without destroying the basically hard lighting. I did this by using a diffuser—in the form of a piece of black nylon from a stocking—over the lens. This kind of diffuser works best with hard lighting because it is particularly effective with specular highlights.

This shot is contrasty in both subject matter and lighting and yet, with the use of proper lighting technique, the subject roundness remains clearly evident.

3

Client: American Commerce Exchange
Camera: Nikon F2
Lens: 105mm
Lighting: Two 2000-watt-second electronic flash heads, one in a Chimera softbox and the other in a spot reflector
Film: Kodachrome 64
Filtration: Amber gel on one light source
Exposure: Between *f*-16 and *f*-22

The purpose of the photos on these two pages was to show how easy it is to get service from the American Commerce Exchange, a company dealing in barter services: You simply pick up the phone and dial! All I needed to show was a phone and a hand. This told the whole story. Less is more!

To reduce unnecessary detail to a minimum, I chose to shoot the entire subject in silhouette for the photo on this page. Because silhouettes have no detail other than their outlines, they must be clearly recognizable as such. This means selecting subjects that have distinct outlines and also shooting them from an angle that preserves the recognizability of the outline. In this photo, everyone immediately recognizes a phone being held in a hand.

To produce the silhouette image, the only lighting came from a softbox aimed at a bright-blue background. The softbox had to be totally behind the subject, so no light would fall on the front of the hand or phone.

For the photo on the opposite page, I lit the hand by placing a small softbox above and slightly to the far side of the hand. To emphasize the warm tone of the hand against the blue background, I used an amber gel on the light source. To maintain viewer attention on the phone and hand, I lit the blue background with a spotlight.

Notice that, for both photos, I supported the phone on a thin shelf. By aiming the camera horizontally at the shelf, I was able to use the shelf to graphically enhance the image.

I like to use bright, electric blue as a dominant color in photos of electronic and other sophisticated, modern equipment. It seems to convey the idea of modern technology particularly well. □

4

Client: Mirage Editions, Inc.
Camera: Sinar-f 4x5
Lens: 250mm
Lighting: Two 2000-watt-second electronic flash heads in 4x6-foot Chimera softboxes; one electronic flash in dish reflector
Film: Ektachrome 64 (Daylight)
Filtration: Colored gel on background light
Exposure: Between *f*-22 and *f*-32

This floral photo was shot for reproduction as a poster. I like monochromatic themes in which one color, and slight variations of that color, are dominant. I selected a background color that closely matched the color of the flowers.

I lit the subject with two 4x6-foot softboxes, one on each side of the vace and a little to the rear of it. These lights provided the rim lighting to the vase. The light on the right side was carefully positioned to also rim light the two protruding ledges on the vessel.

The background was lit by an electronic flash head in a dish reflector.

Although the vase was light in tone, having the light coming mainly from the rear gave it a dark appearance. To minimize light reflection onto the front of the vase, I placed a black cloth in front, just out of the camera's view.

Using a 250mm lens enabled me to shoot from a relatively long distance. This enabled me to place the background well behind the subject without requiring that background to be excessively large. Good spatial separation between subject and background, such as I used here, enables you to light each independently without fear of light spillage from one to the other. Sometimes I'll have the background for a shot such as this one as far away as 20 feet.

I used a plexiglass sheet as base for the vase. It reflected the illuminated background nicely.

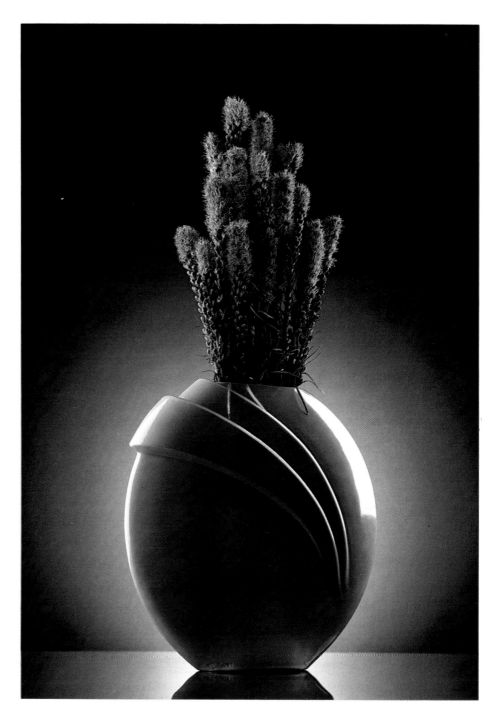

Notice how the bright flowers contrast against a dark background and the dark lower part of the vase stands out against a bright background. This is a small detail, but the kind that can make a lot of difference to the effectiveness of a photograph. □

This photo was intended for a poster. Because posters are generally viewed at about eye level, I aimed the camera horizontally at the violin. This gave the image optimum realism. It's a small detail—but constant attention to such detail makes the difference between competent photography and truly fine photography.

The low camera angle also gave a pleasing graphic effect which was further enhanced by using a long lens and shooting from a fairly long distance.

I placed the only light source, a 4x6-foot softbox, above and slightly to the rear of the violin. This rim lighted the upper outline of the instrument and highlighted the strings. The light source extended sufficiently far forward to illuminate the upper half of the violin body. By placing the violin on black velvet, which reflects virtually no light, I ensured that the lower half of the body remained dark.

I placed a small, white reflector card to the left of the violin to add a subtle highlight to its curved head. ☐

5

Client: Mirage Editions, Inc.
Camera: Sinar-f 4x5
Lens: 250mm
Lighting: One 2000-watt-second electronic flash in 4x6-foot Chimera softbox
Film: Ektachrome 64 (Daylight)
Exposure: *f*-22

Client: Home magazine,
Los Angeles Times
Art Director: Al Beck
Camera: Sinar-f 4x5
Lens: 90mm
Lighting: One 2000-watt-second
electronic flash in 4x6-foot
Chimera softbox
Film: Ektachrome 64 (Daylight)
Exposure: *f*-45

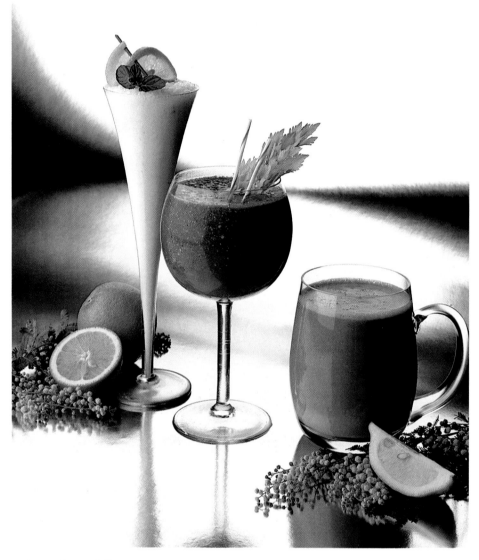

This photo was shot to illustrate an article about health beverages. Art director Al Beck and I agreed that the image should be high-key and cheerful.

The background was a sheet of silver lusterboard. Instead of simply laying it down flat, I decided to do something a little different. I bent it from a horizontal to a vertical position. This enabled me to produce the distinct shadows on the left and right sides. As I've said earlier in this book, the background can play a significant part in the creation of a striking photograph.

This photo is an interesting example of effective composition. First, notice that the main components form a triangle. This helps to keep viewer attention within the picture area.

Notice also how the stem of the left glass intersects the shadow on the orange and how the light rim of the center glass overlaps the shaded side of the left glass. The bright handle of the glass on the right side stands out more clearly by having a patch of shadow behind it. You should always strive to build up tonal separation in this way.

The only light source, a 4x6-foot softbox, was placed to the left side of the camera in a side-light position. It provided the long reflections in the glasses in the center and on the right side. An umbrella light, placed in the same position, would have yielded unattractive, umbrella-shaped highlights.

Sometimes I'll water down transparent drinks to make them appear more brilliant and appetizing in a photo. Because none of the drinks shown here were transparent, watering them down would have served no useful purpose. On the contrary, it would have caused them to lose some of their characteristic "texture."

I tried to maintain a monochromatic color scheme. Notice that all the colors are in the yellow, orange, brown and red range. □

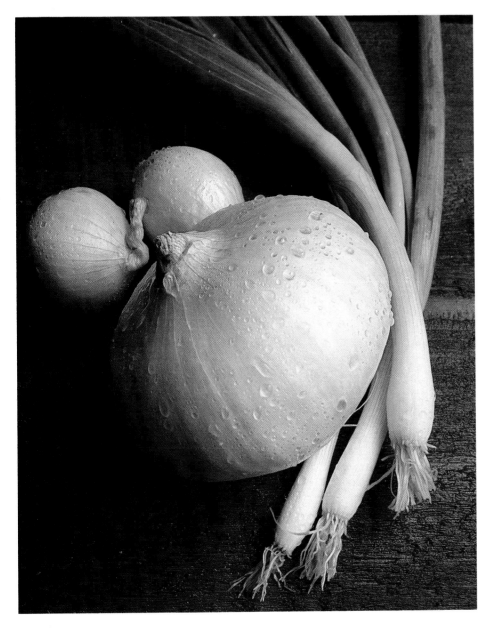

7

Purpose: Experimental photo
Camera: Graphic View II 4x5
Lens: 90mm
Lighting: One electronic flash in 36-inch white umbrella
Film: Ektachrome 64 (Daylight)
Exposure: f-16

This is probably the oldest photograph in this book. It dates back to my student days at the Art Center College of Design. The photo shows that my style has been consistent from the start: the simplicity of design, soft yet directional light, and the use of basically monochromatic color schemes.

The composition was lit by a single flash in a large umbrella. In those days, I had no softboxes. The light was to the right of the camera and no more than 18 inches from the onions. This gave very soft illumination. However, the direction of the light was such that there were distinct shadows and good modeling of the onions.

The green onions and the small ones at the back almost form a circle around the large, central onion. This helps to keep viewer attention in the picture.

Just before taking the picture, I sprayed the onions lightly with water to give them a fresh appearance.

In a delicate subject like this, correct exposure is very important. If the bright part of the onion skin had been a little lighter, much subtle detail would have been lost. Had the exposure been much less, however, the skin would have lost its characteristic glow. ☐

8

Client: Playgirl magazine
Model: Marcy Hansen
Camera: Nikon F2
Lens: 105mm
Lighting: Three electronic flash heads in cone reflectors
Film: Kodachrome 25
Exposure: f-22

Marcy's blond hair and light skin were ideal for high-key treatment. I asked her to wear a white dress and white shoes and posed her against a white, seamless background. The only dark tones in the image are provided by the camera she's posing with.

This was the key picture for a *Playgirl* feature on new camera equipment. The white background of this high-key shot was extended to the second page of a spread. Various items of camera equipment were "stripped" into the white space.

Because Playgirl is predominantly a magazine for women, I took a series of photos of Marcy Hansen together with a male model. However, in the final layout a shot of Marcy alone was featured.

Marcy's blond hair and light skin were ideal for high-key treatment. I asked her to wear a white dress and white shoes and posed her against a white, seamless background. The only dark tones in the image are provided by the camera she's posing with.

As you can see from the preceding essays, as well as the photos in this portfolio, I love the soft light provided by large softboxes. They are also ideal for high-key photography. However, in this case I wanted a little more sparkle and directional illumination than a diffuse light could provide. So I lit the model with three flash heads in cone reflectors. One light was a few inches above my camera. The other two were about one foot to each side of the central light.

A lot of light was thrown back toward the camera from the white background, subtly transilluminating the dress. One 4x8-foot white reflector in front of the model and another behind her completed the shadowless illumination.

To add a little movement to the dress, I used a lightly blowing fan near the camera position. □

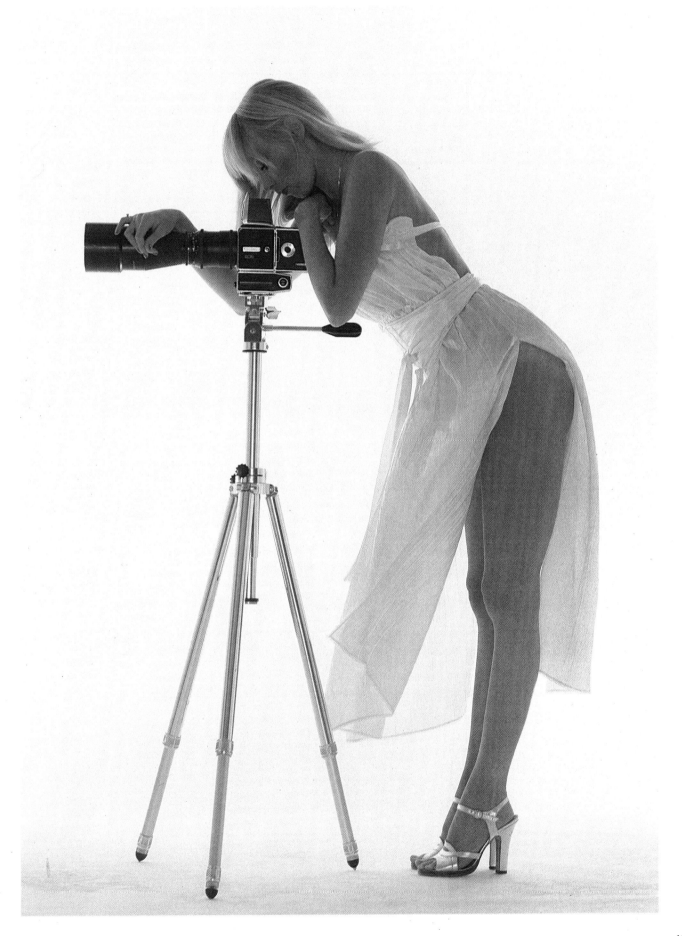

9

Client: Mirage Editions, Inc.
Camera: Sinar-f 4x5
Lens: 250mm
Lighting: Two 2000-watt-second electronic flash heads, one in a 4x6-foot Chimera softbox
Film: Ektachrome 64 (Daylight)
Filtration: Red gel over background light
Exposure: *f*-45

After having produced several posters with lavish floral arrangements, I wanted to try something simple and yet effective. In taking this photograph, I aimed for a dynamic, graphic statement with strong lines and tonal separations. To minimize perspective and keep the image as two-dimensional as possible, and to give prominence to the flower, I chose a low camera angle and used a long lens.

The two steel bars and the stem of the flower lead viewer attention directly to the bloom, which is dramatically isolated against a black background.

The main-light source was a 4x6-foot softbox to the left side of the subject. It illuminated the flower, the vase and the bars. The second light illuminated the background of red seamless paper. To give added saturation to the red of the paper, I used a red gel over the background light.

I positioned the background light very carefully, so the right side of the vase was outlined in red while most of the body of the vase remained in silhouette.

Artists often have the knack of making difficult jobs look deceptively simple. This "simple" image took me three days—and many flowers—to make! □

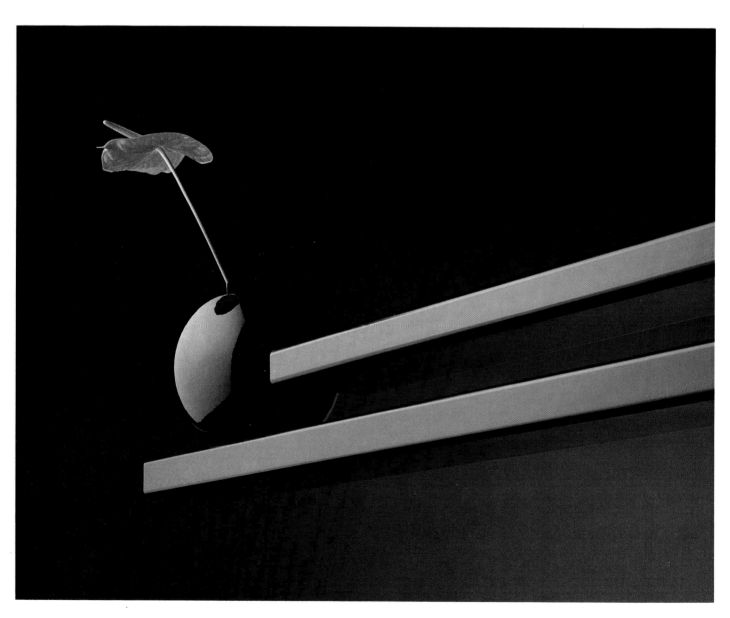

Every good photographer has his own distinct style. Part of mine is simplicity of design. This photograph is a departure from my normal style. If a photographer is to be commercially successful, he must be flexible enough to provide what each client wants.

When a composition contains a lot of props, as does this one, you must be careful to retain viewer attention on the main subject. The main components of this picture are the spinach salad and the casserole dish. Notice that most of the props are either cropped or very close to the picture edge.

The props provide a setting for the main subject, giving the picture a warm, homelike atmosphere. Without props, this would be a simple product shot. By careful placement of all the picture components, no doubt is left in a viewer's mind regarding the purpose of the photograph.

The casserole would not remain fresh-looking as long as the salad. Therefore, I put the salad and all other components in place first and arranged the composition and lighting, leaving room for the casserole. At the last moment, I added the freshly cooked casserole. As you can see, it had an appetizing appearance.

The main light was a 3x4-foot softbox, placed above and slightly to the rear of the set. A gold foil reflector added a warm glow to the left side of the casserole.

The candlelight provide an intimate, romantic atmosphere. To record the flames of the candles, I had to give an

Client: Home magazine, Los Angeles Times
Art Director: Al Beck
Camera: Sinar-f 4x5
Lens: 90mm
Lighting: One 2000-watt-second electronic flash in 3x4-foot Chimera softbox
Film: Ektachrome 64 (Daylight)
Exposure: *f*-32 (2 seconds)

exposure time of 2 seconds in addition to the flash.

In this photo, I wanted a distinct feeling of perspective. To achieve it, I shot downward at an angle from close range, using a wide-angle lens. ☐

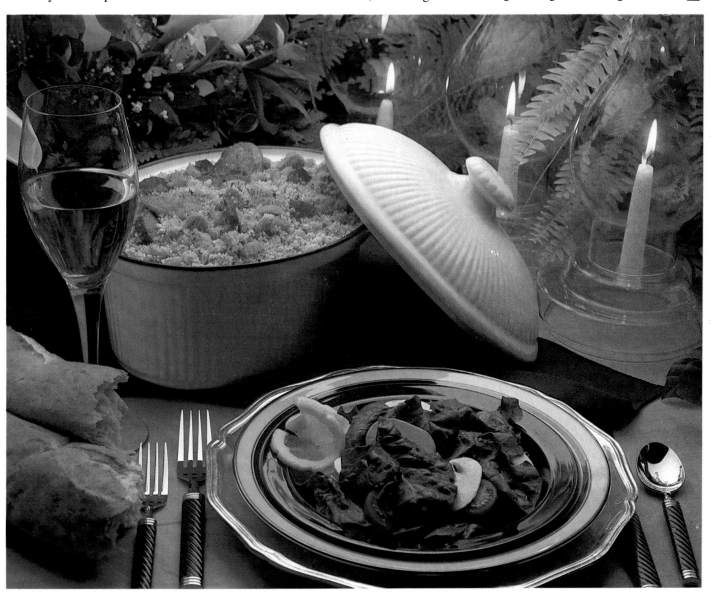

11

Client: Duty-Free Shoppers
Art Director: Linda Katsuda
Camera: Sinar-f 4x5
Lens: 250mm
Lighting: Two 2000-watt-second electronic flash heads—one in 4x6-foot Chimera softbox; the other in pan reflector
Film: Ektachrome 64 (Daylight)
Exposure: *f*-32

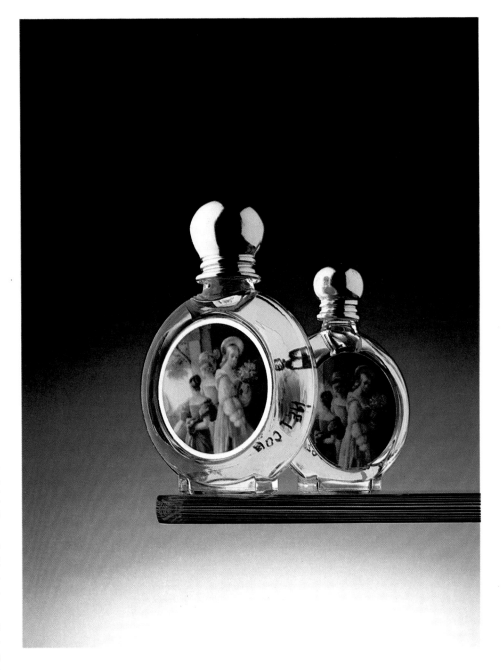

Occasionally, my "studio" photography is not done in my studio. I made this photo in a small room in the duty-free warehouse facility at the Los Angeles International Airport.

Space limitations prevented the background-light control I would have liked. To overcome this problem, I used a 4-foot-wide seamless background paper that is graded from white to a dark blue. Such background paper, available in a variety of colors, is very useful in this kind of shooting location.

I chose blue to contrast with the rich yellow of the liquid in the bottles. To emphasize the gradation of the paper, I directed a flash in a pan reflector at the lower end of the paper.

Notice that I located the shelf for the bottles at the point where the greatest tonal change in the background occurred. This helps direct viewer attention to the bottles.

Although the bottles were barely a couple of inches high, I used a 4x6-foot softbox as main light. I did this to encircle the golden bottle caps with light as far as possible. The softbox was to the left of the bottles.

A white 4x8-foot reflector card to the right of the bottles further illuminated the two caps. It also brought out detail in the label on the farther bottle.

To brighten the liquid in the bottles, I carefully placed a tiny reflector—no larger than half the size of a dime—behind each bottle. Each reflector was angled carefully to direct light from the main source toward the liquid.

Notice that the two bottles and the ledge form a triangular composition. This design helps keep viewer attention within the image area. ☐

Client: Duty-Free Shoppers
Art Director: Linda Katsuda
Camera: Sinar-f 4x5
Lens: 250mm
Lighting: Main flash in 3x4-foot Chimera softbox; background flash in 4x6-foot Chimera softbox
Film: Ektachrome 64 (Daylight)
Exposure: *f*-32

To give this photo of men's eau de toilette a strong, masculine look, I treated the shot almost as architectural photography in miniature. Notice the clean vertical and horizontal lines and the low angle of view. You get the impression of looking up at a tall, imposing structure.

The base on which the bottles are standing was homemade. My assistant had machined ridges into a thick piece of plexiglass.

The main light was a 3x4-foot softbox to the left of the larger bottle. It provided the attractive highlight to the bottle cap and lit the label uniformly. A small reflector card on the right side illuminated the label of the smaller bottle.

The background consisted of a 4x6-foot softbox. It was an easy way of ensuring a uniformly lit background. To get the right tone for the background, I simply adjusted the power setting of the light.

In this photo I emphasized the color of the liquid, not by using a background of contrasting color, but by a total absence of other colors. As you can see, it's very effective. ☐

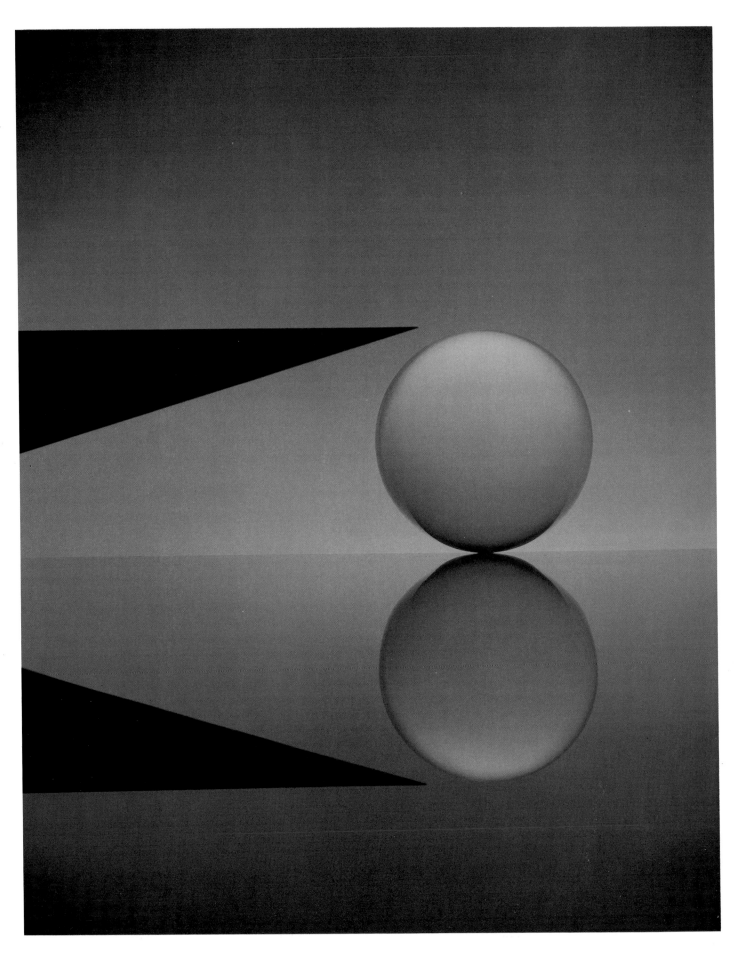

Client: American Commerce Exchange
Art Director: Damian Klaus
Camera: Sinar-f 4x5
Lens: 210mm
Lighting: One 2000-watt-second electronic flash
Film: Ektachrome 64 (Daylight)
Filtration: Blue gel over flash
Exposure: *f*-32

This photo is a good example of the dictum that "less is more." No more subject matter was needed, nor was more light called for. To make a strong visual statement, show only what needs to be shown and leave out everything that's superfluous.

This is a typical example that shows that a professional photographer must be resourceful and self-reliant. The art director and I had arranged to make a futuristic photo of a laser and some related props for the cover of a brochure. At the last moment, we learned that none of the promised equipment was available to us. We had a tight deadline and the cover shot had to be made—even though we didn't have the subject matter.

Fortunately, the only requirement was that the photo be appropriate and decorative. It didn't need to provide any information. So I created this abstract composition with a glass ball, a wedge of black plexiglass and a translucent, reflective base.

I chose blue as the key color because it seems most symbolic of electricity and electronic equipment. To intensify the color of the blue seamless background paper, I used a blue gel over the background light. I chose a low camera angle that provided graphic symmetry between the objects· and their reflection.

The background light was the only light source. It transilluminated the glass ball and provided a pleasing dark-blue hue to the translucent and shiny base. The black wedge and its reflection were deliberately recorded in silhouette.

Notice that the bright top of the ball has a relatively dark background, while the dark base of the ball is against a relatively bright background. Such tonal separations are an important part of creative lighting and image composition.

This photo is a good example of the dictum that "less is more." No more subject matter was needed, nor was more light called for. To make a strong visual statement, show only what needs to be shown and leave out everything that's superfluous. □

14

Client: Mirage Editions, Inc.
Camera: Sinar-f 4x5
Lens: 250mm
Lighting: Two 2000-watt-second electronic flash heads, each in a 4x6-foot Chimera softbox; one electronic flash behind a large diffusing screen
Film: Ektachrome 64 (Daylight)
Exposure: *f*-45

Although it isn't my best-selling floral poster, I like the photo with the white background, on the opposite page, best among all my floral shots. At the poster publisher's request, I also shot the same arrangement with a black background, as shown on this page—and it has actually outsold the other one.

Having pretty well exhausted the background possibilities provided by plexiglass and a variety of horizon variations, I started experimenting with a ledge to support my floral arrangements.

The ledge is made from steel and is heavy. The vases and glass balls are heavy, too, and expensive. In addition, the flower arrangements take a long, long time to perfect. Therefore, it's imperative that such a setup be sturdy and dependable. I needed a lot of counterweighting in the form of bricks and sandbags.

The ledge provides a pleasant design element and, at the same time, draws viewer attention to the floral arrangement.

The arrangement was lit by two 4x6-foot softboxes, one standing vertically on each side. To keep the highlights on each side of the vase—visible against the dark background—uniform in size, it was necessary to position the

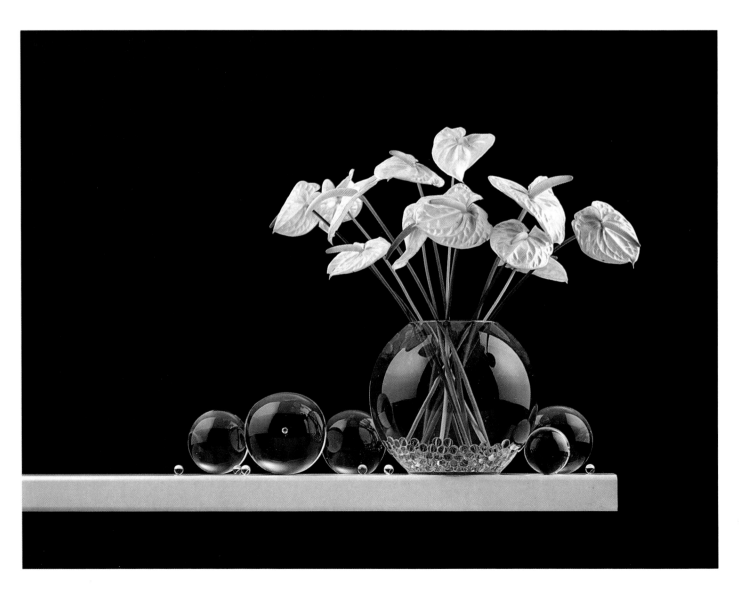

two sources at an equal distance from the subject. This also ensured uniform tonality on all the flowers.

To add sparkle to the flowers in the shot with the black background, I added a third flash, aimed downward through a horizontal diffusing screen.

The backgrounds were created by simply using black and white seamless paper respectively. No special background lighting was used.

To achieve both a pleasing arrangement and optimum lighting on each flower, each flower had to be positioned with great care. □

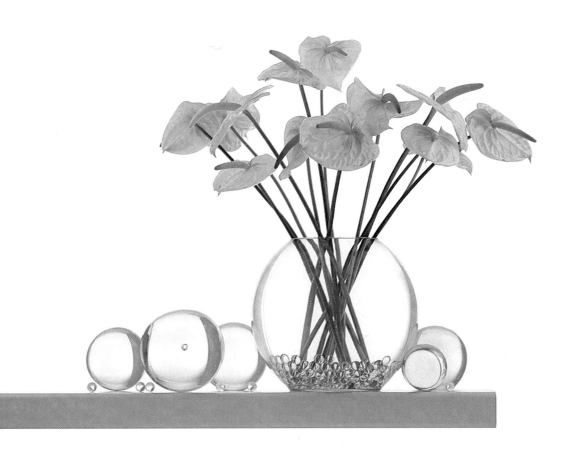

15

Client: Robertson Audio
Ad Agency: Media Design West, Inc.
Art Director: Dave Mangoni
Camera: Sinar-f 4x5
Lens: 250mm
Lighting: One electronic flash in a 3x4-foot Chimera softbox; a second electronic flash aimed at background
Film: Ektachrome 64 (Daylight)
Exposure: *f*-32 (plus 60-second time exposure)

This state-of-the-art amplifier, worth more than two thousand dollars, is an excellent piece of equipment. Unfortunately, it also presents a big challenge to a photographer because it is not exactly photogenic, being nothing more than a black metal box.

To add a little mystery, I placed the right side of the unit in deep shadow. The shadow served a second purpose: it showed the little glowing light all the more prominently.

Notice that the bright, left side of the unit is clearly visible against the dark background. To make the dark, right outline stand out equally prominently, I aimed a single flash at the blue seamless background.

I lit the front face of the unit with a 3x4-foot softbox, placed toward the right edge of the unit so the angle of reflection toward the camera would be equal to the angle of incidence of the light. This yielded the attractive glow in the gray face of the unit. With a black card, or gobo, I blocked off the light from the right side of the unit.

A small makeup mirror was placed toward the rear edge of the left side of the unit, just out of the camera's view. It reflected some of the main light onto the unit's cooling fins to give the vertical highlights.

I used a blue background because I think it is the most appropriate color for modern electronic equipment. However, I selected the blue also because it complemented and reinforced the blue of the lettering on the unit.

In order to record the little light on the right side of the unit, I gave a 60-second time exposure in addition to the flash exposure. While the exposure was being made, all other lights in the studio, including the modeling lights on the flash, had to be turned off. □

Client: Jeffrey Benjamin
Camera: Graphic View II 4x5
Lens: 90mm
Lighting: One electronic flash behind 6x6-foot diffusing screen; a second flash in a 2x3-foot Chimera softbox
Film: Ektachrome 64 (Daylight)
Exposure: f-32

This was just one case of five that I had been asked to photograph. Each case had a different wood pattern and tone and it was essential to show these differences clearly in the photos. I was also asked to bring out the characteristic shine of the wood in each case. I had an interesting lighting problem to solve: How do I show shine without losing surface detail?

Instead of using a softbox, I used a flash head behind a large diffusing screen. In this manner, I was able to put the flash head at precisely the correct position and distance from the diffuser. I placed the diffusing screen above and toward the rear of the case. The flash was about 12 inches from the screen.

Notice how the left side of the upper face of the case and the rounded edge glow while the right side shows more grain detail. The top light served a second important purpose: it dramatically highlighted the brass fixtures.

A 2x3-foot softbox was aimed at the large, vertical surface of the case in such a way that surface reflections were avoided and the grain was clearly revealed. A small reflector card just to the left of the case highlighted the logo on that side of the case.

The background and base consisted of a sheet of black lusterboard. It gave a pleasing reflection of the case rather than a shadow. The light above the case provided enough reflection from the lusterboard to outline the case's reflection and the lower, left edge of the case.

To enhance the perspective of the case, I shot from relatively close range, using a wide-angle lens. ☐

17

Purpose: Experimental Photograph
Camera: Sinar-f 4x5
Lens: 210mm
Lighting: Mole-Richardson tungsten spotlight
Film: Ektachrome 64 (Tungsten)
Filtration: Homemade diffusion filter
Exposure: 1 second at f-22

This experimental photo represents a departure from my normal manner of operation. I used tungsten illumination instead of electronic flash and hard spotlighting instead of my usual soft illumination.

I aimed the spotlight from the left side of the camera, creating classic Rembrandt lighting. The Dutch painter Rembrandt commonly used directional side or side-to-back lighting to create strong highlight and shadow effects in his portraiture.

With a subject such as this fruit arrangement, hard side lighting calls for careful placement of the image components so that no unpleasant or confusing shadows result.

A white reflector card on the right side directed some light into the shadow areas, reducing subject contrast and increasing image detail.

Because the main illumination came from the left side, that side of the subject received more light than the right side. The effect was all the more noticeable because the light was very close to the subject. To compensate for this, I placed the dark grapes to the left side and the brighter fruit to the right.

I used a home made diffusion filter—consisting of petroleum jelly smeared onto a UV filter—to soften the image a little. Diffusion filters are most effective with hard light sources such as the spotlight used for this photo.

Notice how both the shape and color of the napkin on the right complement the pears on the left side. ☐

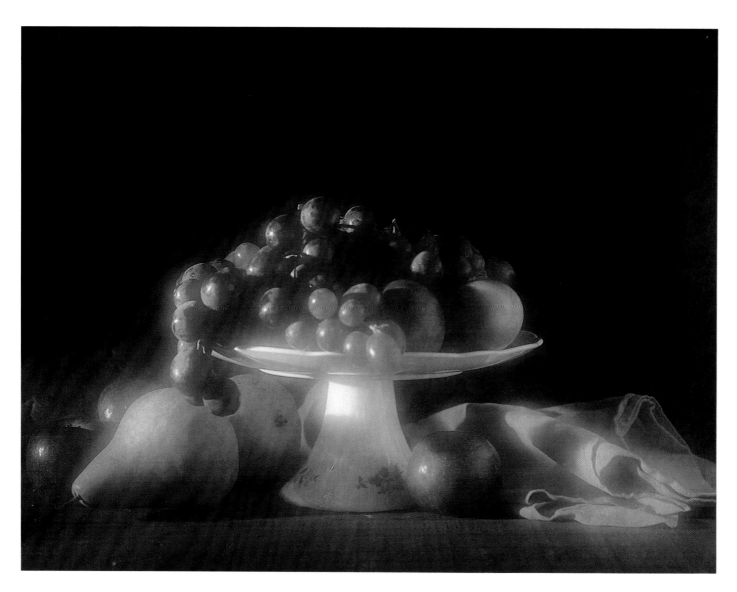

The editors of Home magazine had asked me to shoot a feature on the preparation of an intimate dinner for two. After shooting several detailed photos of the table setting and food, I needed a key photo featuring human interest.

I photographed our attractive model at a dessert-buffet table. The shooting took place in my studio. To make the set look as authentic as possible, we brought in a couch—even though only a small part of it is visible on the left side of the picture. Photographically, a little can often go a long way. Or, less is more!

A buffet table would normally be against a wall. However, this arrangement would have made it impossible to shoot a front view of the model. So we exercised poetic license and pulled the table away from the wall. This enabled me to shoot the pleasing composition reproduced on this page.

I placed a 4x6-foot softbox to the left of the set at a height of about seven feet. It was the only light source.

This photo is yet another example of the need for compromise—a characteristic often demanded of photographers. When the model, camera and light were all exactly where I wanted them for best effect, a reflection of the softbox was visible in the glass on the art hanging on the wall. □

18

Client: Home magazine, Los Angeles Times
Art Director: Al Beck
Camera: Nikon F2
Lens: 105mm
Lighting: One 2000-watt-second electronic flash in 4x6-foot Chimera softbox
Film: Kodachrome 64
Exposure: f-22

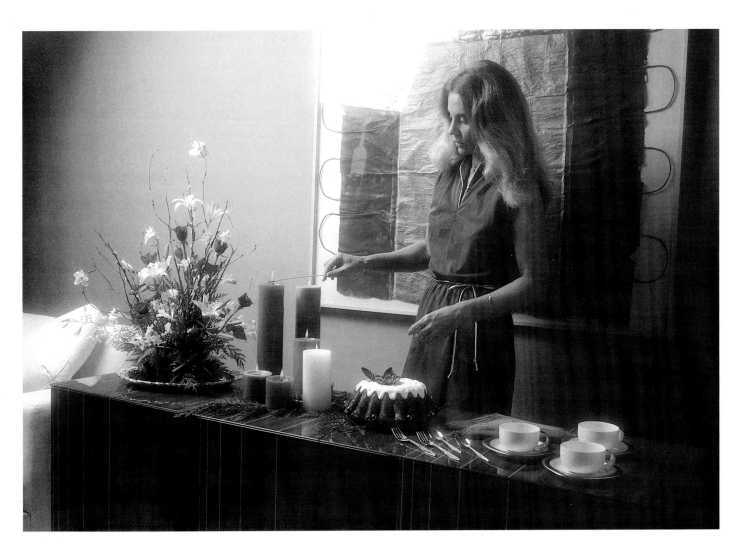

19

Client: Home magazine,
Los Angeles Times
Art Director: Al Beck
Camera: Nikon F2
Lens: 50mm
Lighting: Direct sunlight
Film: Kodachrome 64
Exposure: 1/125 second at *f*-11

This is one of many typical examples in photography where patience and good judgment are essential. Had I not waited, I would not have achieved the dramatic lighting evidenced in this photo. However, had I waited longer, in the hope of getting an even better effect, the glasses might have been removed one by one for the serious business at hand—the tasting of Scotch!

I had been assigned by *Home* magazine to shoot a Scotch-tasting event at the Occidental Towers, a modern high-rise in the heart of Los Angeles. The glasses shown here were set up in preparation for that event. That's why each glass has a number on its base.

I had been asked to shoot as unobtrusively as possible, so took little flash equipment with me on the assignment. The room had lots of large windows and there was ample artificial ceiling lighting so that available-light photography was no problem.

I wanted to photograph the glasses as they were lined up, awaiting use. However, the only light on them came from the ceiling and the effect was less than exciting. I waited patiently and my patience eventually paid off. By about 3 p.m., a low sun was lighting the glasses, creating dramatic, long shadows. Fortunately, the sunlight totally overpowered the ceiling lights.

The shadows play as important a part in this graphic composition as do the glasses themselves.

This is another of many typical examples in photography where patience and good judgment are essential. Had I not waited, I would not have achieved the dramatic lighting evidenced in the photo reproduced here. However, had I waited longer, in the hope of getting an even better effect, the glasses might have been removed one by one for the serious business at hand—the tasting of Scotch! ☐

20

Purpose: Personal promotional photo
Camera: Sinar-f 4x5
Lens: 250mm
Lighting: Two 2000-watt-second electronic flash heads, each in a 4x6-foot Chimera softbox
Film: Ektachrome 64 (Daylight)
Exposure: *f*-32

A dark wine that looks appetizing to the eye may appear very unattractive in a photograph. If, in the final setup or in a test photo, wine looks too thick and a little like motor oil, don't be afraid to water it down. Be careful, however. If you overdo it, the wine will look thin and watery.

Another way to bring out the brilliant color of red wine is to back light it. For this photo, I did that by using a 4x6-foot softbox as background.

The main light, another 4x6-foot softbox, was placed to the left of the set. It produced the attractive, long highlights on bottle and glass. Such highlights are important. Not only do they provide sparkle, they also give form to the objects that reflect them.

Composition had to be handled very carefully because I had no props to rely on. The glass and bottle alone had to produce an attractive photo. Notice the use of empty space on the right side to balance the image and provide some visual impact. Notice also how I have placed the light rim of the glass against the dark part of the bottle.

A newly poured liquid usually has some air bubbles on the surface. By the time I get to photograph a setup, however, a liquid has usually lost its bubbles. To give this glass of wine a fresh look, I produced bubbles just before I shot.

I poured a few drops of Photo-Flo—a wetting agent—into the wine and stirred it. I then injected air bubbles into the wine with an eyedropper. The bubbles remained long enough for me to shoot my photo. If you're not successful in producing satisfactory bubbles, try changing the concentration of the wetting agent in the liquid. □

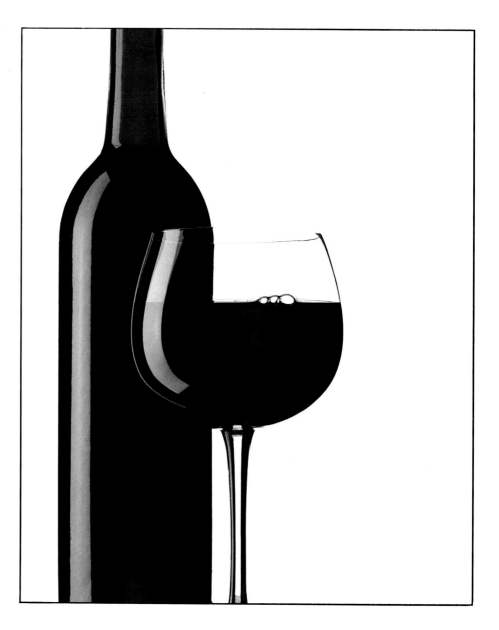

Shooting one shrimp is very different from shooting a bowl of them. Here, a single shrimp was my main subject and I had to treat it as such. It had to be positioned and lit with great care. It even had to be selected with great scrutiny.

In preparation for this assignment for *Home* magazine, we had bought more than two hundred dollars' worth of shrimp. They wouldn't fit into the studio freezer, so we placed most of them in ice in the studio bath tub. After the shoot, I had to get rid of them. Here's a wonderful way to win friends and influence people: give them $50-worth of shrimps!

For ease of operation, I chose to use my Nikon SLR with a macro lens that can give 1:1 image magnification without the need for extension tubes.

I emphasized the brightness of the knife by reflecting a lot of light from it. A single flash head was placed about six inches behind a diffusing screen. This provided a spotlight effect on knife and shrimp. It also gave attractive small highlights to the shrimp which, nonetheless, had an overall soft appearance.

The lighting was too soft to produce distinct shadows. Notice how I have used the dark reflections of knife and shrimp in the reflective base to produce a shadow-like effect.

To get the one, final image, I shot many different shrimp, with shell and without, and with water beads in different parts of the composition. The water beads actually consisted of 25% glycerin in water. This produces better-looking and longer-lasting beads. □

Client: Home magazine, Los Angeles Times
Art Director: Al Beck
Camera: Nikon F2
Lens: 50mm macro
Lighting: One 2000-watt-second electronic flash behind 6x6-foot diffuser
Film: Kodachrome 64
Exposure: Between *f*-22 and *f*-32

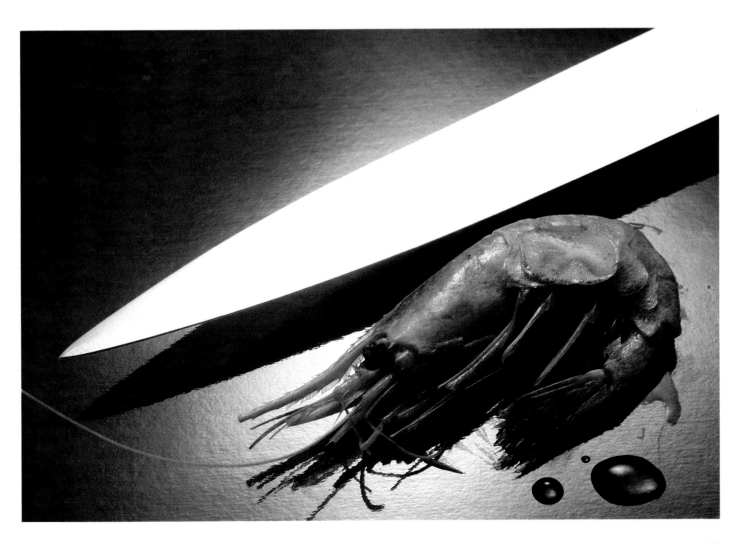

22

Subject: Sculptures by Patrick Nagel
Client: Mirage Editions, Inc.
Art Director: Ben Cziller
Camera: Sinar-f 4x5
Lens: 250mm
Lighting: Two electronic flash heads in a 4x6-foot Chimera softbox; background flash in pan reflector
Film: Ektachrome 64 (Daylight)
Filtration: Color gel on background light
Exposure: f-45

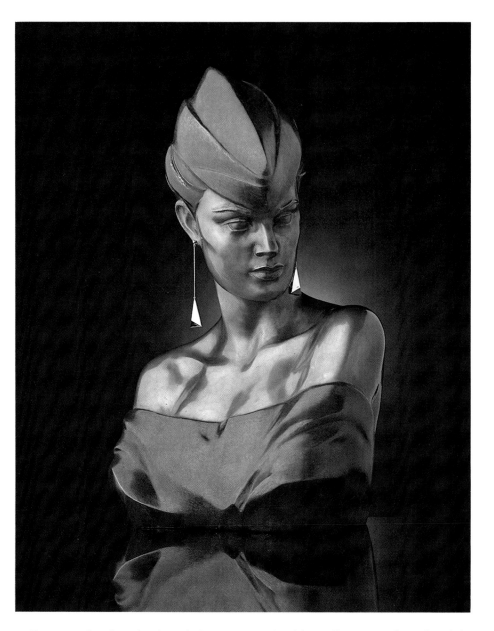

Recording sculpture and other works of art on film demands certain restraints on the part of a photographer. For example, the main purpose in photographing the two magnificent sculptures by Patrick Nagel, reproduced on these pages, was to show the pieces with as much form and detail as possible. It would have been inappropriate to do all kinds of "creative" photographic tricks on this assignment. The viewer should get the impression that he's looking at the sculpture itself rather than a photograph.

To make the photo on this page, I placed a 4x6-foot softbox to the left of the camera. The large light source ensured large, soft highlights in the bronze statue. A small light source would have resulted in small, harsh highlights that would have been totally inappropriate.

A white reflector card to the right of the camera filled the shadow areas. However, reflector cards can often do more than merely fill shadows. They can act as secondary light sources that create their own effects. That's why I rarely place a reflector card near the camera position.

To achieve just the right violet color for the background, I used seamless paper of approximately the right color and then fine-tuned the color with a violet gel over the background light. Notice how the background light is positioned to clearly outline the dark shoulder.

Because the face is tipped downward, I had to shoot from a relatively low angle to show the features to best advantage.

I had to take particular care in placement of the chrome earrings. I wanted them to reflect light rather than dark objects in the studio. The placement was so critical that the only sure way to see the final effect was to look at the camera's groundglass image.

The photo on the opposite page was made with the same light source, at approximately the same angle. However, the light was farther from the subject. This made it effectively a smaller source. The result is relatively harder lighting.

A white reflector card on the right side lightened the shadows. By placing the reflector slightly to the rear of the figure, it also provided a subtle edge light to the figure's left arm.

To concentrate viewer attention on the figure, I chose a black background. To achieve the blue halo around the upper body of the figure, I directed a light with a blue gel at the background from about two feet away.

I shot from a low angle to emphasize the tallness and stateliness of the figure. However, to avoid distortion I shot from a considerable distance, using a 250mm lens. □

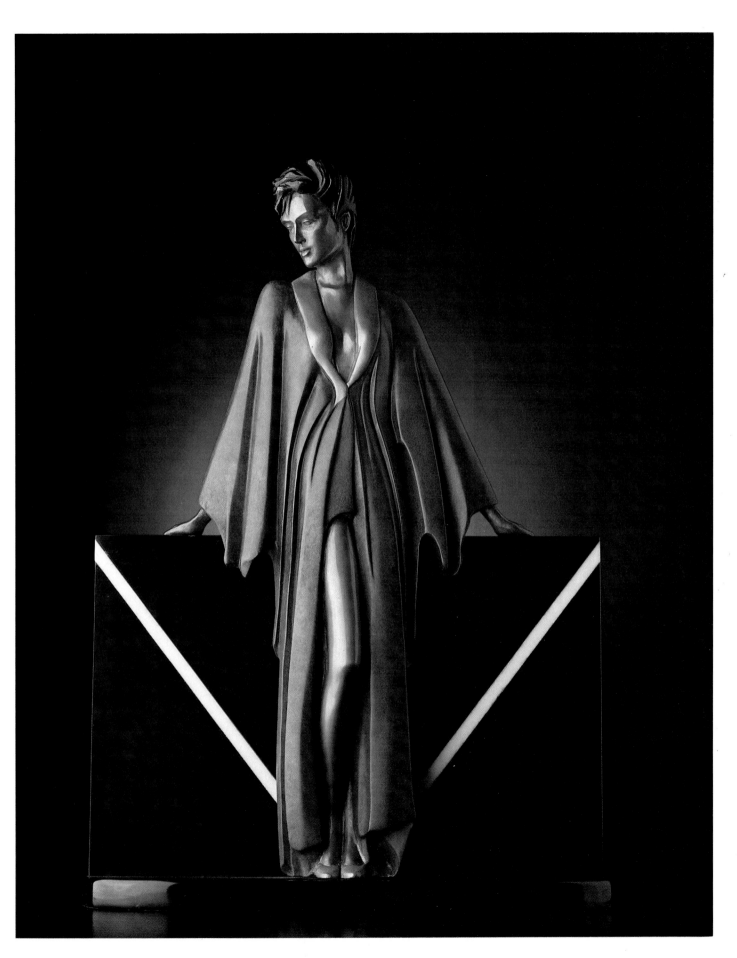

23

Purpose: Experimental photo
Camera: Sinar-f 4x5
Lens: 150mm
Lighting: One 2000-watt-second electronic flash in 4x6-foot Chimera softbox
Film: Ektachrome 64 (Daylight)
Exposure: Between *f*-32 and *f*-45

This experimental shot demonstrates clearly how little frontal light can sometimes be sufficient to produce an effective photograph. My intention was to create a "mood" shot rather than a detailed image of the bottle.

Even the name *Halston* is partly in shadow. By lighting the name from the left, where we start reading, it's relatively easy to recognize the name, even though it isn't all visible. If I had lit the right end of the name and allowed the beginning to fall into shadow, name recognition would have been much more difficult.

Lighting consisted of a 4x6-foot softbox and a small paper reflector. I placed the softbox a few inches to the left of the bottle and mostly to the rear of it. This gave the farthest part of the bottle the brightest highlight, lending a glowing quality to the bottle. This kind of lighting, placing the brightest highlight next to a dark background, is always particularly dramatic.

I brought the light just far enough forward to make most of the name on the bottle legible.

I used a sheet of white 8-1/2x11-inch paper near the right edge of the bottle as reflector. To maintain a black background, the bottle was standing on black velvet, which absorbs almost all the light striking it. □

Client: Mirage Editions, Inc.
Camera: Sinar-f 4x5
Lens: 250mm
Lighting: Two electronic flash heads in 4x6-foot Chimera softbox
Film: Ektachrome 64 (Daylight)
Exposure: *f*-32

This photo was intended for a poster. I chose a simple subject and composition, together with a subtle color that would fit well into most domestic color schemes.

Because the picture was to contain only three elements, their placement was crucial to the production of an effective image. To create a balanced, yet dynamic, composition I placed the vase at the rear on a wooden block to make it appear taller. I then had to be careful to hide the wooden block from the camera's view.

Pure, white backgrounds that don't also burn into the edges of the subject are difficult to achieve. The brightness ratio between background and subject must be just right. It helps to place the background as far as possible from the subject. Then, the background illumination tends to affect the subject edges less.

The subject was on a sheet of white plexiglass. Because I wanted to eliminate the "horizon" line, I had to use enough background illumination to "burn out" the line in the image.

The frontal reflection in the plexiglass enhances the image without adding too much complexity to the composition.

The lighting came from a 4x6-foot softbox, aimed horizontally at the left side of the vases. To get large highlights, I placed the softbox very close to the vases. I didn't want to lighten the shadows on the right side. On the contrary, I placed a black cloth on that side, to absorb as much of the main light as possible.

The composition purposely included a generous area of empty space. A tight crop would have been much less effective and pleasing. ☐

Subject: Cassandra Gava
Camera: Nikon F2
Lens: 105mm
Lighting: One 2000-watt-second electronic flash in seven-foot umbrella
Film: Kodachrome 64
Filtration: Weak, homemade diffusion filter
Exposure: f-16

To enhance the statuesque appearance of the model, I shot from a low angle. I avoided image distortion from that angle by shooting from a relatively long distance, using a 105mm telephoto lens.

I made this shot for two portfolios—mine and that of my subject, successful actress and model, Cassandra Gava. Cassandra had agreed to pose for me in return for photographs.

At the outset, we had no particular poses in mind. We simply wanted to produce some attractive, sensual pictures. I asked Cassandra to wear black and placed her in front of a black background. This brought out her light skin tones and fine lines to best advantage. To enhance the glamour of the shot, I asked Cassandra to stand on a large mirror.

Illumination came from a flash in an umbrella seven feet in diameter. It was placed well to the left of the camera. The lighting was soft, the contrast of the image being provided mainly by tonal differences between black and the light skin. The umbrella light also gave a sparkling highlight to Cassandra's hair.

A large silver-foil reflector, placed to the right of the camera position, evened out the illumination and lightened shadows.

To enhance the statuesque appearance of the model, I shot from a low angle. I avoided image distortion from that angle by shooting from a relatively long distance, using a 105mm telephoto lens.

To slightly soften the image, I used a diffusion filter made by smearing a very small amount of baby oil onto a UV filter. It caused the subtle light flare from the bracelet. ☐

26

Client: Mirage Editions, Inc.
Art Director: Karl Bornstein
Camera: Sinar-f 4x5
Lens: 250mm
Lighting: Electronic flash in a
4x6-foot Chimera softbox;
6x24-inch strip light
Film: Ektachrome 64 (Daylight)
Exposure: *f*-32

The photographs on these two pages represent part of the experimentation that goes into the production of a finished poster. The publisher selected the vases and suggested the floral arrangement. From these basics, I changed the color scheme to present several variations on the basic theme.

I used a monochromatic color scheme in both photos. When I changed to the red background, I also changed from black to red vases.

The main light in each case was a 4x6-foot softbox to the left of the vases. This light produced the highlights on the left of the vases, giving them form—even in the silhouette. A long, narrow strip light, placed to the right of the vases, provided highlights on the red vases and a rim light on the black ones, separating them from the black background.

The base for the red vases was black plexiglass. It reflected the red background nicely, almost completely eliminating the "horizon" between background and base.

I felt that any visible base in the dominantly black picture would distract from the vases and the floral arrangement. For this reason, I placed the bottom of the vases on the picture edge. Of course, doing this requires very accurate image framing. When a photo is to be reproduced, such as in this book, a little safety margin must be left to allow for cropping.

In the photo on this page, notice the subtle backlighting that graphically separates the lower part of the black vases from the background. ☐

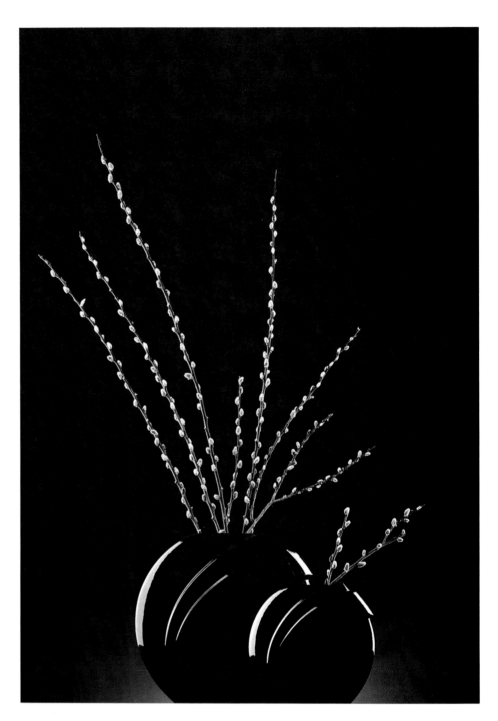

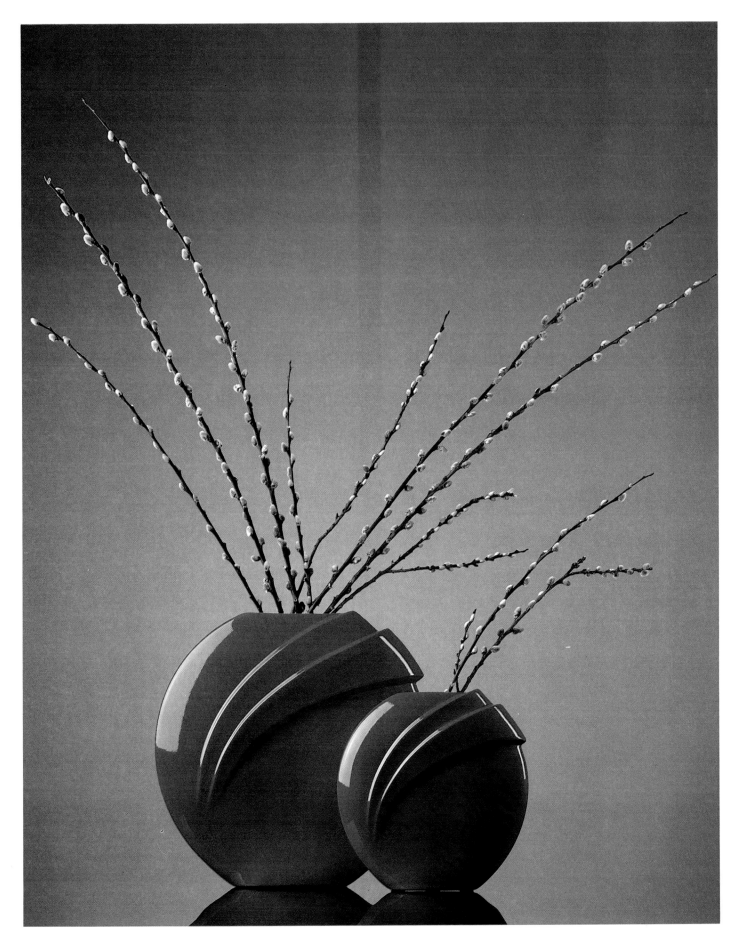

27

Client: Protype
Ad Agency: Larsen, Colby & Koralek Advertising
Art Director: Gary Larsen
Camera: Sinar-f 4x5
Lens: 250mm
Lighting: One electronic flash in a 4x6-foot Chimera softbox; three electronic flash heads in 36-inch umbrellas
Film: Ektachrome 64 (Daylight)
Exposure: *f*-32

An advertising photographer must often follow tight, predetermined layouts. In the photo reproduced here, not only did the word processor have to occupy a specified image part, it also had to be shot from an angle that showed its features the way the client wanted to see them. However, meeting requirements specified by an art director need not reduce a photographer's scope for creativity. On the contrary, restrictions bring with them the challenge of getting the most esthetically pleasing result while, at the same time, communicating the client's message.

As you can see from many of the other photos in this portfolio, lighting and lens selection offer a lot of scope for creativity.

If I had used a standard lens while shooting from the camera angle that satisfied my client, the word-processor screen would have appeared disproportionately large. To minimize perspective distortion, I used my 250mm lens and moved the camera much farther away from the subject.

To maintain the camera angle required by the client, however, I now had to raise the camera to a height of about 10 feet.

It was important to show detail in all parts of the word processor. To create a three-dimensional effect, I also wanted each of the two sides and the top of the unit to have a different tonality.

Using a boom stand, I aimed a 4x6-foot softbox straight down on the unit from above. This gave the brightest illumination to the upper surface. I positioned the softbox carefully, so the front of the unit received a little more light than the left side.

The uniform, white background—where type would eventually be inserted—was lit by three flash heads in umbrellas.

Incidentally, I shot the image on the word-processor screen separately and had it stripped into place in the final reproduction. To ensure a proper fit, it was essential, of course, to shoot the screen from the same location as the general photo shown here. ☐

Sometimes I like playing with diverse objects that have interesting shapes and interact in an exciting way with light. When I produce photographs of them, I prefer calling them *photo-graphics* rather than photographs.

The glass marbles featured in this photo had been left in my studio by an art director and had been lying there for months. I took them out, added some square Cokin color filters and a Kodak color conversion filter, and started experimenting.

I placed a bare flash—without reflector—in several positions and watched what the modeling light would do to the transparent objects.

This photo was made with the bare flash about six feet behind the set. The hard, point-source light was transmitted and refracted by the glass, forming distinct frontal shadows and interesting color patches.

It's very difficult to assess correct exposure for subtle subjects such as this, so I bracketed my exposures liberally.

The compositional and design possibilities offered by objects such as the ones shot here are virtually unlimited. The shadows created must always be regarded as an integral part of a composition.

When using bare flash, be careful not to allow it to strike the camera lens directly. Keep the source behind the camera or shield it from the lens. Otherwise, your photos will be spoiled by lens flare. ☐

Purpose: Experimental photograph
Camera: Nikon F2
Lens: 50mm macro
Lighting: One bare electronic flash
Film: Kodachrome 25
Exposure: *f*-22

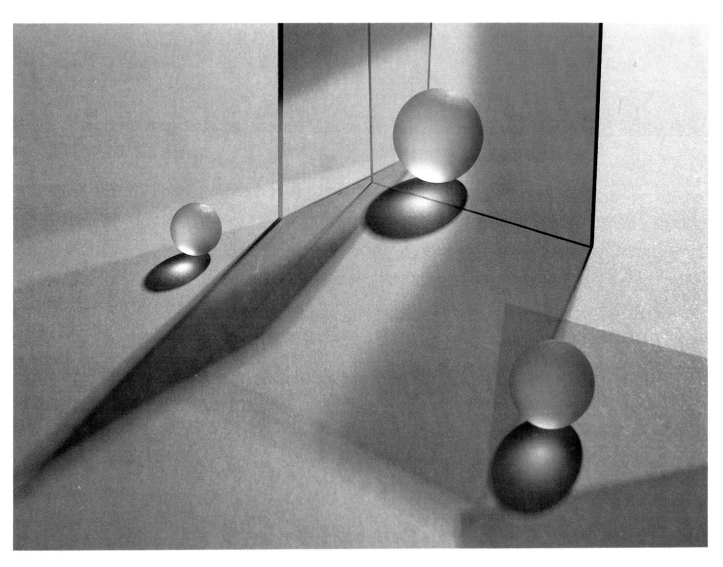

29

Client: Proto Tools
Camera: Sinar-f 4x5
Lens: 90mm
Lighting: One 2000-watt-second electronic flash behind 6x6-foot diffuser
Film: Ektachrome 64 (Daylight)
Exposure: *f*-32

I had been assigned to photograph a Proto wrench. The client had not decided on a specific setting or composition and asked me to shoot the product in several ways. Of course, several shots cost the client more than one shot. However, it isn't uncommon to be asked to provide several variations on a basic theme, even when only one photo is to be used.

Sometimes the variation consists of no more than subtle changes in lighting or camera angle. In this case, I shot three totally different compositions but used basically similar lighting.

I positioned a 6x6-foot diffusing screen over the subject and slightly to the rear of the set. A single flash head was placed about 18 inches behind the screen. This provided the broad highlights that give the chrome wrench its characteristic luster.

Exposing the two photos on this page correctly for the wrench caused the remainder of the image to be underexposed—precisely the effect I wanted. The background for the photo on the opposite page was black, so "underexposure" for it was no problem.

Incidentally, the photo on the opposite page was shot vertically downward, even though it appears that the hand is extended vertically. □

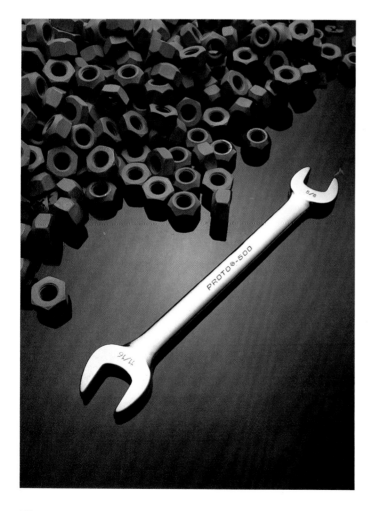

30

Client: Home magazine, Los Angeles Times
Art Director: Al Beck
Camera: Nikon F2
Lens: 105mm
Lighting: Two electronic flash heads in a 4x6-foot Chimera softbox; two flash heads in umbrellas; one flash head in cone reflector
Film: Kodachrome 64
Exposure: Between *f*-16 and *f*-22

I had been commissioned to photograph some items of warm winter clothing for publication in *Home* magazine, the supplement for the Sunday *Los Angeles Times*. The two garments shown here were a cross between sleeping bags and large coats.

A happy, upbeat mood was requested for the photos. That's why I used a white background. I chose frontal subject lighting for the same reason, as well as to ensure adequate illumination on both faces, which were facing in different directions.

To avoid the inconvenience of shooting at floor level, I posed my subjects on a sturdy rolling table. This enabled me to shoot an apparent floor-level picture while having the camera at a comfortable eye-level height.

I achieved the uniform background illumination with an umbrella flash on each side and a third flash in cone reflector hidden behind the table. In the printed reproduction in the magazine, much of the white space was used for type.

Main subject illumination came from a 4x6-foot softbox, placed about six feet above the camera and slightly to the right. In addition to illuminating the two models nicely, this gave an attractive luster to the red garment. □

The location for this photo was not a bedroom or a showroom in a store but a corner in my studio. My assignment was to feature bed linen sold in different department stores. At the time this set was built, I had three other full-scale sets in my studio. As I've indicated earlier in this book, studio sets can consist of anything ranging from a simple sheet of seamless paper to a complex set that resembles a fully furnished room in a home.

To create authenticity without distracting attention from a featured product, some parts of the set—such as the plant on the right—can be shown only partially.

I used three light sources. The main area of the bed was lit from above with a flash aimed through a horizontal 4x4-foot diffuser or scrim. A second light was placed low and aimed at the right side of the bed. The third flash was placed behind the headboard. Notice how it graphically separates the headboard from the wall on the extreme right side.

I kept the shutter open long enough to also record the glow from the small lamp beside the bed.

This set is lit basically in the same way I would light a small table-top model of a similar set. The only difference would be in the scale: the size and distance of the lights would be proportionately smaller. □

31

Client: Home magazine, Los Angeles Times
Art Director: Al Beck
Camera: Nikon F2
Lens: 35mm
Lighting: Three electronic flash heads
Film: Kodachrome 64
Exposure: f-32

Client: United Silver and Cutlery
Ad Agency: Josh Freeman
Design Office
Art Director: Cheryl Lewin
Camera: Graphic View II 4x5
Lens: 210mm
Lighting: One 2000-watt-second
electronic flash in a 4x6-foot
Chimera softbox
Film: Ektachrome 64 (Daylight)
Exposure: *f*-32

My challenge in making this photo was to eliminate most of the unwanted reflections and yet give the image sufficient contrast and "snap" to make it interesting. I used a 4x6-foot softbox with the flash head close to its diffusing surface. This gave an overall soft light together with subtle specular illumination.

This photo was one of several shot for possible use on silverware packaging.

Shiny objects are always difficult to light. When they are flat, they reflect large areas around them. When they are curved, like spoons, they can reflect almost everything in the immediate environment.

My challenge in making this photograph was to achieve a soft lighting that would eliminate most of the unwanted reflections and yet give the image sufficient contrast and "snap" to make it interesting.

I placed a 4x6-foot softbox above and slightly to the rear of the set and as close to the subject as possible. This was the only light source. The flash head was close enough to the diffusing surface of the softbox to yield distinct shadows.

Because the angle of reflection equals the angle of incidence, proper lighting of shiny objects is dependent on three factors: the position of the lights, the position of the camera and the angle at which each shiny surface is placed. To reduce the reflection of dark studio areas in each spoon, I placed some white cards in strategic positions. You can clearly see their reflections in the spoons.

I had intended to aim the camera down vertically. However, this would have given a reflection of the camera in the knife and possibly in the other pieces also. So I got as close to a vertical view as I could without causing undesirable reflections.

To make the wooden table fade to darkness at the top of the image, I shielded the light from the softbox with a large, black card at that location.

As a final touch, I put three air bubbles in the wine just before I made the exposure. □

33

Client: Duty-Free Shoppers
Art Director: Linda Katsuda
Camera: Sinar-f 4x5
Lens: 250mm
Lighting: Two electronic flash heads in a 4x6-foot Chimera softbox; one flash strip light
Film: Ektachrome 64 (Daylight)
Exposure: *f*-32

This excellent cognac looked appetizing to the eye but would have recorded rather like heavy motor oil on film. To do the product justice in a photo, I had to water it down.

The first step was to remove the cap and replace it as if it had never been touched. We carefully slit the bottle-cap sleeve down the back side. We removed some cognac and replaced it with water. We repeated the procedure until I felt the cognac had the right transparency and color for photography.

The cap was returned to the bottle and the sleeve was taped back into place, with the giveaway cut hidden on the rear side.

I placed the main-light softbox to the left of the bottle. I turned the bottle slightly toward the light until the labels were clearly legible.

A strip-light flash was aimed at the right side of the background. Its reflection from the background provided a pleasing rim light to that side of the bottle. Its reflected light also transilluminated the bottle sufficiently to give the cognac a warm-red glow.

When back lighting is not practical, the glow and color of a liquid can be brought out by placing a small reflector behind the bottle.

I placed the bottle near the join of the dark and light background areas. There, it attracts viewer attention most effectively.

To emphasize the warm-red glow of the cognac, I used a subtly blue background for contrast. □

Purpose: Photo for my portfolio
Camera: Sinar-f 4x5
Lens: 90mm
Lighting: One 2000-watt-second electronic flash in 3x4-foot Chimera softbox
Film: Ektachrome 64 (Daylight)
Exposure: f-45

When you study the reproductions in this portfolio, you'll notice that I have a tendency to shoot low-key images—with lots of dark tones and plenty of contrast—rather than high-key photos. I shot the photo reproduced on this page specifically to add to my collection of high-key shots.

The subject was simple: a bottle, its cap and a few tablets. The investment in props was probably no more than one dollar and yet here were the makings of an excellent still-life photograph—one that might eventually bring in thousands of dollars' worth of work.

I used silver foil as base for the subject components. A main-light softbox was high and to the rear of the subject. It gave form to the bottle, its cap and to the tablets. No fill light was needed because the foil base acted as a very efficient reflector.

This image shows that a photo can be high-key and at the same time not lack modeling and even a measure of contrast. ☐

Purpose: Cover photo for this book
Camera: Hasselblad
Lens: 250mm
Lighting: Two electronic flash heads in a 4x6-foot Chimera softbox; one flash head behind white plexiglass; two electronic flash heads in pan reflectors
Film: Ektachrome 100 (Daylight)
Exposure: *f*-22

The photograph on the cover of this book shows the basic setup for this shot. A large softbox on the right side of the camera provided the main illumination. It provided soft lighting on the model and attractive, large highlights on the scooter. I added light to the left side by placing a flash head about six feet behind a 4x8-foot sheet of white, translucent plexiglass near the back of the scooter. The background was lit by two flash heads in pan reflectors.

In an advertising photograph of this kind, it's important to concentrate viewer attention on the main subject—in this case, the Honda scooter. To do so, I had my model, Tawny Moyer, wear red to correspond with the red of the scooter. A contrasting color would have taken too much attention from the scooter and directed it to Tawny.

To emphasize the scooter, I shot up from a low angle. A telephoto lens and accordingly long shooting distance enabled me to avoid distortion in the image. □

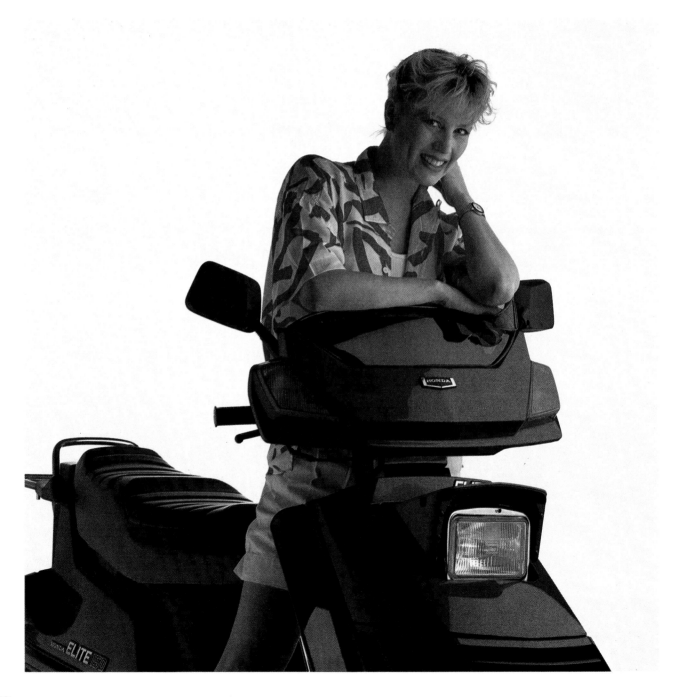

Client: American Commerce Exchange
Camera: Nikon F2
Lens: 35mm
Lighting: One electronic flash behind diffuser; a second electronic flash with honeycomb snoot
Film: Kodachrome 25
Filtration: Deep-red gel on background light
Exposure: *f*-22

It's not easy to produce exciting photos of such mundane objects as credit cards. Fortunately, my client was willing to go for something a little on the abstract side.

To concentrate viewer attention on the American Commerce Exchange credit card, we surrounded it with other cards that we had painted black. Although the black cards projected in front of the featured card, I was careful not to obstruct any of the information on that card.

The cards were on black lusterboard. The red coloring comes from a deep-red gel, placed over the background light. The red light was passed through a diffusing screen and aimed carefully to hit the background but miss the featured card.

The main flash, in a honeycomb snoot, was carefully aimed at the central card. I moved it about, little by little, until I had the exact lighting effect I wanted. Notice that the card is not lit uniformly and that the highlighted golden lettering stands out well from the darker base.

The foreground area received just enough light to show a separation between it and the black cards. ☐

37

Client: Lipman Publishing
Camera: Sinar-f 4x5
Lens: 210mm
Lighting: One electronic flash in 4x6-foot Chimera softbox; another electronic flash in cone reflector
Film: Ektachrome 64 (Daylight)
Filtration: Red gel on background light
Exposure: Between *f*-22 and *f*-32

Financially, this has been my most successful photograph to date. I'm sure its great success as a poster is in large part due to the use of striking color and tone combinations— red, green, black and white.

Financially, this has been my most successful photograph to date. I shot it for publication as a poster by Lipman Publishing. I'm especially happy about the success of this picture because I had named it *Brooke's Bouquet,* after my daughter Brooke.

My stylist for this shot, Catherine Brustine Collins, had chosen the vase and arranged the flowers. Up to that point, I had no idea of how I was going to shoot the arrangement.

When I saw the red vase, I immediately decided to keep the theme red throughout. I enhanced the red of the seamless background by illuminating it with a red gel on the light source.

The background light, in a cone reflector, was placed close to the background, yielding a distinct circle of light surrounded by darkness.

To light the flowers, I placed a 4x6-foot softbox to the left of the arrangement. A white reflector card of about equal size was on the right side to help balance the illumination.

Compositionally, notice how the red circle of light on the background reinforces the circle of the vase and the circular flower arrangement.

The vase was on a sheet of black plexiglass, which reflected the red background beautifully. The slight upward curve of the "horizon" helps draw viewer attention toward the vase and the flowers.

To give the arrangement a larger-than-life look, I shot from a low angle. To minimize perspective and achieve the graphic effect so suitable for posters, I shot from a relatively long distance, using a lens of longer-than-standard focal length.

I'm sure that the great success of this poster is in large part due to the use of striking color and tone combinations—red and green, and black and white. ☐

38

Client: Home magazine, Los Angeles Times
Art Director: Al Beck
Camera: Nikon F2
Lens: 35mm
Lighting: Daylight through studio skylights
Film: Kodachrome 64
Exposure: 1/8 second at *f*-16

The attractive lighting in these two photos would not have occurred if I had not used two characteristics essential for every creative photographer—being flexible and observant.

As you know, one of my main attractions to studio photography is the total control it offers. That's why I always close my skylights when the time comes to set up lights and shoot. Well, not *quite* always!

In this case, I noticed the beauty of the daylight striking the furniture through my main skylight as we were setting up for the shoot. I immediately decided to shoot in that light at the same time on the following day.

I was observant enough to see a special situation when it presented itself. And, I was flexible enough to break my own rules.

Because my studio has a very high ceiling, the large skylight functioned as a medium to small light source, giving clear but soft shadows. It simulated soft, diffused sunlight. Coming from a high angle, this light was ideal for the tropical furniture I was shooting.

Because the light source was fixed, we had to move the furniture about until we got the best possible lighting. By opening and closing the blinds on the skylight, I was also able to control the size of the source.

To lighten the shadows on the set, I opened other, smaller skylights. Their light fell in such a way that it did not affect the nature of the main illumination.

I took several photos of different furniture in this series. In each case, I had to work fast because of the constant movement of the sun. □

39

Client: Home magazine, Los Angeles Times
Art Director: Al Beck
Camera: Nikon F2
Lens: 50mm
Lighting: Two 2000-watt-second electronic flash heads in 4x6-foot Chimera softbox; two electronic flash heads in umbrellas
Film: Kodachrome 64
Exposure: f-22

This photo was part of a magazine feature on the preparation of mu-shu pork. After shooting a series of photos showing the preparation of the food, I needed a key shot of an Oriental dinner party, with guests enjoying the prepared meal.

With nothing more than a couple of bamboo screens and some wicker furniture and props, we converted a corner of my studio into a very convincing Oriental home.

Having set up the buffet, I selected a high camera angle to clearly show the various dishes. I directed my two models to hold their two plates in the positions shown. Apart from that, I gave them the freedom to interact with each other as they wished while I watched and exposed film.

I aimed a 4x6-foot softbox at the set from a high angle and a distance of about 15 feet. I wanted uniform, soft illumination for two reasons. First, I wanted to create a happy, upbeat atmosphere. Second, this light made it easy for the subjects to move without the possibility of generating unflattering shadows.

To create the effect of daylight coming through the bamboo screens, I directed two flash heads in umbrellas at the white wall behind the screens.

Notice the plant on the left side of the image. It is a subtle, yet important addition, making the scene look more like a home than a studio set.

Purpose: Test photo for use on package
Ad Agency: Josh Freeman Design Office
Art Director: Cheryl Lewin
Camera: Graphic View II 4x5
Lens: 90mm
Lighting: One 2000-watt-second electronic flash
Film: Ektachrome 64 (Daylight)
Exposure: *f*-45

This was a test shot, for possible use on a package. The composition had to be planned carefully to fit a specified layout.

In many of my photos, especially those made for posters, I try to achieve a strong two dimensional, graphic effect. This generally calls for a head-on view and a relatively long lens. In this photo, I wanted the opposite—dramatic perspective. I aimed the camera down at an oblique angle from close to the subject, using a wide-angle lens.

I placed the silverware on a sheet of black plexiglass. I love this as a base because it shows beautiful, dark reflections of the subject while eliminating shadows.

To avoid unwanted reflections from the surrounding studio area, I placed a 6x6-foot translucent scrim over the subject. The scrim was angled so that the part farthest from the camera almost touched the table.

I lit the scrim from behind, near where it approached the table. Because this produced brighter lighting at the back, the plexiglass base gradually gets lighter from front to back. This helps to create a feeling of distance. Notice that no corresponding brightness falloff is noticeable in the silverware because it is so highly reflective.

The red rose added a final touch to the image. To give the rose "life," I gave it a dewy look by spraying it lightly with a 25% solution of glycerin in water. ☐

Purpose: Speculative cover shots for Playboy magazine
Camera: Nikon F2
Lens: 105mm
Lighting: Two electronic flash heads in a 4x6-foot Chimera softbox; two flash heads in umbrellas; one flash head in cone reflector
Film: Kodachrome 64
Exposure: *f*-22

Marcy Hanson, a former *Playboy Playmate,* had modelled for me on several previous occasions. We decided to speculatively shoot a cover for *Playboy* magazine.

I decided to include the famous bunny theme in the form of a balloon. Other balloons surrounded the model. Originally I had intended to have the balloons floating in the air. However, having them on the floor appeared to make for a more pleasing composition that concentrated viewer attention on the model more effectively.

So that I could shoot comfortably from what appears to be floor level, I had Marcy stand on my rolling table. This placed her about three feet off the ground.

I wanted a summery, high-key shot. The white background wall was lit by an umbrella flash on each side and a flash in cone reflector in the center. Using the table made it easy to conceal the center background light from the camera.

As main light I used a 4x6-foot softbox well to the left of the camera. To keep shadows to a minimum and thus retain the high-key effect, I placed a white 4x8-foot reflector card to the right of the camera.

The model's delicate skin tones are shown to best effect because the image contains no competing colors.

The low camera angle emphasizes Marcy's long legs and statuesque form. To avoid unflattering distortion from such an angle, it's important to shoot from an adequate distance. Using a 105mm lens enabled me to shoot from a distance of slightly more than 20 feet. ☐

42

Client: 1928 Jewelry Co.
Ad Agency: Karen Golay
Marketing Communications
Art Director: Karen Golay
Camera: Sinar-f 4x5
Lens: 250mm
Lighting: Two 4x6-foot Chimera
softboxes, each containing a
2000-watt-second electronic flash
Film: Ektachrome 64 (Daylight)
Exposure: *f*-45

The saxophone was to be a background or prop for the display of jewelry. Originally, the art director and I had planned to actually attach the jewelry items to the saxophone. However, eventually we decided that this treatment might cause the saxophone to overpower and upstage the jewelry.

We decided to make a high-key shot of the saxophone alone and then add a separate image of the jewelry items to the background of this delicate image.

The first step was to have the saxophone painted white. We then attached the instrument, upside down, to a light stand. To get the exact angle of the saxophone in the image, I tilted the camera slightly to one side. The result, when the image was turned top to bottom, was the photo reproduced here. The saxophone appears approximately in its normal playing position.

The background consisted of a 4x6-foot softbox, aimed directly at the camera. I adjusted the light output until I got the background brightness I wanted.

The main light was another 4x6-foot softbox. It was to the left of the upside-down saxophone. Together with a large, white reflector card on the other side, this gave very soft, almost shadowless lighting. ☐

The client wanted a post card that was a little out of the ordinary, to draw attention to the company's "soft-sculpture" penguins. I decided to place the penguins in a studio setting that showed much of the photographic process involved.

To emphasize the characteristic black-and-white of penguins, I limited the entire scene to black and white. Without the red in the power pack of the flash, the shot might almost have been made on b&w film.

Notice that the black seamless paper is shown in rolled form at floor level. This was part of the process of deliberately showing a "working" set.

The composition was carefully thought out. The penguins were placed under the main-light umbrella, where they attract most attention. For added emphasis, the bright boom arm points toward the penguins. Graphic tonal separation is provided by the extension of the white bodies into the black background.

The main light was the umbrella flash. However, another flash, in pan reflector, was bounced from the studio ceiling above the set. It lit the top of the umbrella and extended the highlight on the boom arm. To maintain the clean, white look of the penguins, I placed a large, white reflector card on each side of the set. □

Client: Laughing Cat Design Company
Camera: Graphic View II 4x5
Lens: 210mm
Lighting: One electronic flash in six-foot umbrella; one electronic flash in pan reflector
Film: Ektachrome 64 (Daylight)
Exposure: Between *f*-11 and *f*-16

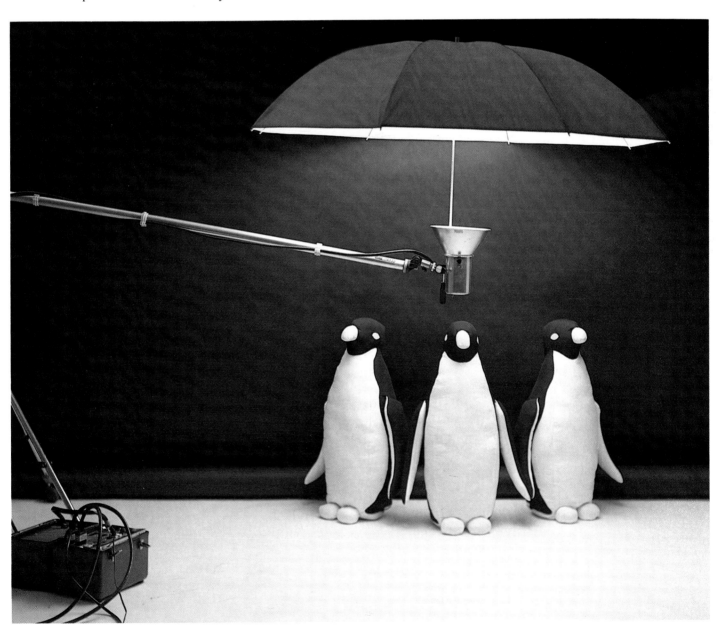

44

Purpose: Personal photograph
Camera: Sinar 8x10
Lens: 350mm
Lighting: One 2000-watt-second electronic flash in 3x4-foot Chimera softbox
Film: Ektachrome 64 (Daylight)
Exposure: *f*-45

Lighting and composition are inextricably linked. Had I changed the angle of the illumination, all shadows would have changed. Most probably, I would have had to re-arrange all three peppers to get the best composition once again. Conversely, had I moved the peppers about, I would almost certainly also have had to change the light angle.

Peppers are classic still-life subjects for painter and photographer alike. A close look at this photo may explain why. Their varied shapes lend them to an infinite variety of angle of view, composition and lighting.

I don't normally enjoy using an 8x10 camera. However, after an assignment I had the rented 8x10 camera all to myself for a few hours and couldn't resist doing my own classic pepper shot in the large format.

Notice how lighting and composition are inextricably linked. Had I changed the angle of the illumination, all shadows would have changed. Most probably, I would have had to rearrange all three peppers to get the best composition once again. Conversely, had I moved the peppers about, I would almost certainly also have had to change the light angle.

I chose a black background and a nearly black foreground. The darkest parts of the peppers are silhouetted against the slightly brighter foreground area. This was done quite deliberately. The bright areas on the peppers are well defined against the black background.

By placing the main light—a 3x4-foot softbox—in a low position behind the peppers, I was able to achieve a halo rim light that makes the peppers glow, giving them an almost translucent appearance.

To add a little detail to the sides of the peppers, I used an 8x10 reflector card on each side, close to the peppers.

With an 8x10 camera, depth of field is always limited, especially when shooting at close range. I needed to stop the lens down to *f*-45 to ensure sharp focus over the subject. ☐

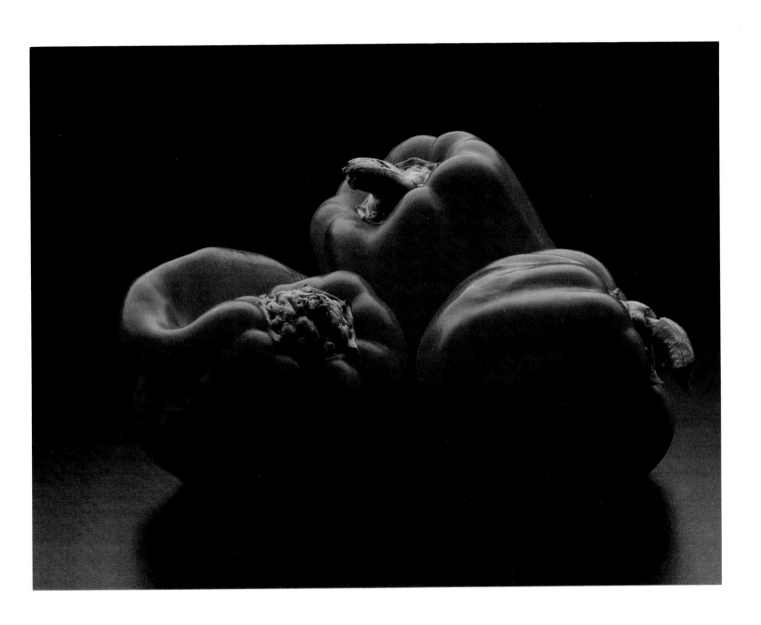

Client: Rova-Pro
Art Director: Damian Klaus
Camera: Nikon F2
Lens: 105mm
Lighting: One electronic flash in 3x4-foot Chimera softbox; one electronic flash in cone reflector
Film: Kodachrome 25
Filtration: Deep-blue gel on background light
Exposure: Between *f*-22 and *f*-32

I had been asked to photograph one of the first car phones on the market. Because this type of product was relatively unknown, the client suggested that I show not only the phone but all the electronic components that made up the equipment.

The lighting was simple—just one softbox and a flash in a cone reflector. However, *simple* is not the same as *easy*. Getting the subtle effect I wanted demanded very careful placement of the lights.

To make my job even more difficult, I decided to shoot this black product against a black background. I thought it would make for a dramatic and elegant shot.

To concentrate attention on the phone itself, I lit the background directly behind it with a spot of deep-blue light. This light reflected from the plexiglass base on which the equipment stood, providing good tonal separation for the lower side of the large unit.

The main-light softbox was to the right of the camera and aimed at the subject at an angle of nearly 90° to the camera's direction of view. At camera position, this light produced a pleasing luster in the black equipment.

An interesting point: Notice that, although the background is black and the equipment is black, there is good tonal separation between them. That's because the luster just mentioned gives the equipment a tone much lighter than black. However, there can be no doubt in a viewer's mind that the equipment is, in fact, black.

I allowed the left side of each component, where there was no detail to show, to fall into deep shadow. ☐

Client: The magazine Flowers &
Art Director: M.J. Cody
Camera: Nikon F2
Lens: 50mm
Lighting: One electronic flash in 4x6-foot Chimera softbox; two electronic flash heads in umbrellas
Film: Kodachrome 25
Exposure: *f*-32

I had been shooting floral arrangements regularly for the monthly magazine *Flowers &*. Much of the time, I used plain seamless-paper backgrounds. For this simple display, I wanted to do something different.

I decided to use a venetian blind. Photographers often use them for projecting parallel shadow lines onto a background. In this case, I chose to include the blind itself in the photo as background. Two umbrella flashes uniformly lit the white wall behind the blind.

The vase was reflected nicely by the highly reflective sheet of black plexiglass on which it stood. The plexiglass also reflected the blind in a way that made it difficult to tell where the blind ended and its reflection began. In effect, this setup created a form of "seamless" background.

A 4x6-foot main-light softbox was placed to the left of the vase. This yielded good modeling in the vase, the flowers and even the flower stems. To maintain contrast, I didn't use a reflector on the other side to brighten the shadows.

This photo is yet another good example of the axiom that "less is more." If I had added any other props, the image would have lost much of its impact.

47

Client: Home magazine, Los Angeles Times
Art Director: Al Beck
Camera: Nikon F2
Lens: 35mm
Lighting: One 2000-watt-second electronic flash behind a 6x6-foot diffusing screen
Film: Kodachrome 64
Exposure: f-22

The surest way to draw viewer attention to a bowl of soup in a photo is to photograph nothing but the soup. However, just a bowl of soup, sitting in the middle of an otherwise empty photo, makes for a very dull picture. When I made the photo reproduced on this page, my intention was to suggest the setting for an intimate dinner for two while, at the same time, making the soup the most prominent feature.

There are many props in this picture and yet your eye always travels back to the bowl containing the soup. Directing viewer attention in this manner can be achieved in several ways. Notice, for example, that most of the props surrounding the soup are cropped by the picture edges. This immediately gets across the message that the props play a secondary role to the main subject.

The soup is contained within several concentric circles formed by the bowl and the plates. These circles hold your attention and direct it toward the center. In addition, the large white area around the soup helps draw attention to the glistening, reddish surface of the soup.

Although every item in the picture is lit in an attractive manner, only a single light source was used. I positioned a large diffusing screen above and slightly to the rear of the set and placed a single flash behind the screen. The lighting is soft, yet yields sufficient shadows to retain some contrast. The silverware, glass and china have just the right amount of luster and the soup has an appetizing glow overall. To add emphasis to the color of the soup, I used a table and napkins of similar hues. □

In contrast with the photo on the opposite page, this is a very simple image, showing little more than a bowl of popcorn. I find this kind of experimental photography invaluable in sharpening my perception and improving my lighting technique. It also presents a wonderful challenge to create an impressive image with limited subject matter.

If you want to experiment with food photography, choose food items that don't spoil quickly. Many fruits and vegetables are suitable, as are breads and cookies.

I lit the subject in a way that created contrast and good tonal separation. The light popcorn at the top is graphically separated from the dark background. The popcorn at the bottom of the bowl is dark, contrasting well

against the light coming through the base of the bowl.

I used just one light source—a flash in pan reflector. To soften the illumination, I aimed the flash through a large diffusing screen. Because I wanted to retain some directional quality in the illumination—and get some sparkle in the popcorn—I placed the flash no more than twelve inches from the diffuser. If the light had been much softer, the image would have lost much of its "life."

To bring some detail into the sides of the bowl, I placed a white reflector card close to each side of the bowl, just out of camera view. I did not place a reflector card in front of the subject because I wanted to retain the deep frontal shadow. □

48

Purpose: Experimental photograph
Camera: Sinar-f 4x5
Lens: 210mm
Lighting: One electronic flash, in pan reflector, behind 6x6-foot diffusing screen
Film: Ektachrome 64 (Daylight)
Exposure: f-22

49

Purpose: Experimental photograph
Camera: Hasselblad
Lens: 80mm
Lighting: One electronic flash in six-foot umbrella; one spotlight flash; one flash in cone reflector
Film: Ektachrome 64 (Daylight)
Exposure: *f*-16

I had been shooting a series of photos for the model's portfolio when we decided to do some experimenting. This whimsical, perhaps slightly erotic image shows once again that less can be more.

To bring out the model's beautiful skin tone and hair color, I deliberately avoided any other color in the image.

Even though electronic flash is of very short duration, I was fortunate in getting a little movement in the fan blade. It adds life and credibility to the image.

To get the striped background effect, I aimed a flash in a cone reflector through parallel slots cut from a piece of cardboard.

The main flash was in a six-foot umbrella, almost frontal to the model. I aimed a spotlight at her right shoulder from the rear, producing attractive rim lighting on her right arm and adding a little luster to her hair.

When shooting a feature on wallpaper hanging, I wanted one photo that showed not just the procedure, but the *action*. I did it by accompanying a sharp image with some image blur. It involves using flash to get the frozen image and tungsten light to achieve the blur of the moving subjects.

Some experimentation is usually necessary to achieve the required amount of blur. Polaroid film is very useful for making such tests because the image can be examined almost immediately after shooting.

You can achieve a blur in two ways. You can either move the camera during the exposure, in which case everything in the scene will blur in the same direction and to the same extent. You can also depend on your subjects for the blur. In the case of the photo reproduced here, I had the camera on a tripod and asked the subjects to carry on their normal activity while I gave a sufficiently long exposure to record their movements.

A bare tungsten bulb, placed to the right of the camera, was aimed partially through the venetian blind. This produced the streaked effect on the male subject. Because I used daylight-balanced color film, this light also gave a somewhat warm color effect.

As main flash, I used a ring light around the camera lens. This light, used most commonly for medical and technical photography, can be very useful in producing shadowless illumination.

The flash exposure produced the sharp part of the image. The blur was produced by the tungsten light during a shutter speed of 1/8 second. □

Client: Home magazine, Los Angeles Times
Art Director: Al Beck
Camera: Hasselblad
Lens: 120mm
Lighting: One electronic flash ring light; one bare tungsten bulb
Film: Ektachrome 64 (Daylight)
Exposure: Between *f*-16 and *f*-22 (1/8-second shutter speed)

51

Client: East-West Network magazine
Art Director: Sandi Silbert
Camera: Sinar-f 4x5
Lens: 90mm
Lighting: One 4000-watt-second electronic flash in 4x6-foot Chimera softbox
Film: Ektachrome 64 (Daylight)
Exposure: Between *f*-32 and *f*-45

Food can lose its appealing, fresh appearance very quickly. For this reason, I'll often ask the stylist working on an assignment with me to provide "stand-in" food. It resembles the real thing sufficiently to enable me to compose the shot, arrange the lighting and determine exposure. Only when I'm ready to shoot, is the real food brought before the camera. It comes straight from preparation and has an accordingly appetizing appearance. Once the real subject matter is before the camera, I work as fast as I can.

Good food photography is the result of the team work of three experts— photographer, stylist and art director. Often, the preparation of the food alone takes hours. Sometimes a dish will not turn out just right and has to be prepared all over again.

Notice that all the items in this photo, whether cooked or not, look fresh and appetizing. Even the beer has an appealing head of foam. We poured several beers before we got the result we wanted. When we eventually got it right, I shot as quickly as I could. Here's a useful tip: Sometimes it's possible to "revive" the foam on beer by adding a small amount of salt.

The beer was dark. To give it more life, I placed a small silver-foil reflector behind the glass. Without it, the beer would have looked more like motor oil! The same reflector served a second purpose: It rim lighted the dish next to the beer mug.

Food generally looks best in a soft top light coming slightly from the rear. This highlights the glow of certain items and creates distinct but soft frontal shadows to give the food form. I placed a 4x6-foot softbox in the position just indicated. To get the background dark, I shielded the light in that area with a black card. Notice how the bright items at the back of the image stand out against the background.

I kept the softbox far enough back to enable me to produce the shadow area at the front of the image.

I used two small gold reflectors on the left side. One highlighted the burrito and gave it a warm glow; the other put a reflection in the left side of the beer mug. Finally, to add a glow to the tomatoes in the top, right corner of the picture, I placed a white 8x10-inch reflector card to the right side of the tomatoes. ☐

Almost anyone can learn to take good still-life photographs. If you have a camera, you need little else to get started. This photo is a good example. The subject was a couple of pears. The "set" consisted of a sheet of black velvet. Lighting came from a softbox. Window light could have been used instead.

Any additional props or equipment would not only have been superfluous but might have led to a less impressive image. For example, I deliberately avoided including other objects or colors. The subtle coloring of the pears is best brought out against a neutral background. I also avoided using any form of fill light. I wanted deep shadows.

The softbox was to the right of the pears. Both it and the pears were positioned so the shadow on one pear overlapped a highlighted area on the other.

To give the image a somewhat ethereal atmosphere, I shot through a weak diffusion filter, made from glycerin smeared lightly on a glass UV filter.

To minimize perspective and give the image a strong graphic appearance, I shot with a long, 210mm lens. □

Purpose: Experimental photograph
Camera: Sinar-f 4x5
Lens: 210mm
Lighting: One 2000-watt-second electronic flash in 2x3-foot Chimera softbox
Film: Ektachrome 64 (Daylight)
Exposure: *f*-22

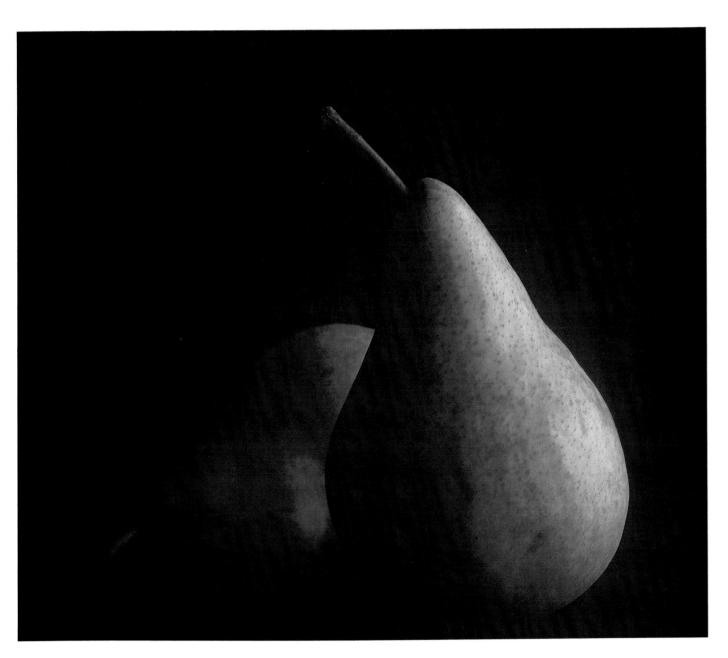

53

Client: Duty-Free Shoppers
Art Director: Linda Katsuda
Camera: Sinar-f 4x5
Lens: 90mm
Lighting: One electronic flash in a 2x3-foot Chimera softbox
Film: Ektachrome 64 (Daylight)
Exposure: *f*-45

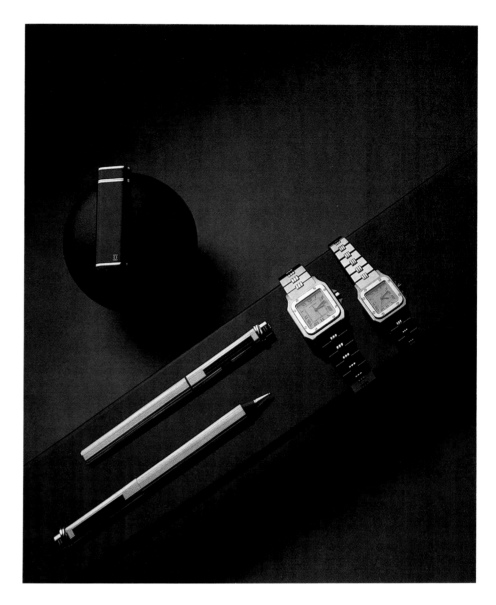

This was one of the rare occasions when I shot on location. My "studio" was a small room at Los Angeles International Airport. The assignment was to shoot a series of photos for backlit point-of-purchase displays.

Because there had to be some continuity in the series, we decided to use geometric shapes as background props in each shot. In the shot reproduced here, the shapes are very subtle because the entire background is very dark. We wanted a dark background, to emphasize the reflective articles featured in the image.

The only light used was a 2x3-foot softbox. It is particularly useful for shooting on location because it is very compact and lightweight.

I placed the softbox above the subject and slightly to the rear. This ensured good reflections in the gold and in half of each watchband. It also gave subtle reflections on the gold in the frontal halves of the bands. I placed a white reflector card in front of the objects to lighten the shadow side a little.

To avoid unwanted reflections in the watches, I moved the camera and light slightly until I could clearly see detail in each of the watch faces.

Because jewelry and similar accessories are small, they usually have to be shot from close range. As image magnification increases, so does the evidence in an image of fingermarks, dust and dirt. It's important to keep the items to be photographed and their background clean. ☐

A model agency will generally indicate each model's particularly strong features. For example, one model may have fine hands, with well-shaped fingers and good nails. She would be particularly valuable for close-up shots of objects being held or used. Another model may have a particularly beautiful face. She would be useful in a wide variety of applications, including the advertising of makeup or eyeglasses and as a general spokesperson for a product or organization.

Bonnie Steves, the model featured in this photo, has unusually attractive legs. She is ideal for photographs featuring stockings, swimsuits or even motor scooters.

In this photo—part of a test session—I wanted to feature Bonnie's legs. To emphasize her statuesque, elegant appearance, I shot from a low angle. I used a 150mm lens on my Hasselblad. It enabled me to shoot from a sufficient distance to avoid image distortion.

For added glamour, I asked Bonnie to wear high-heeled shoes. To give the photo the appearance of an advertisement, I gave Bonnie a product to hold—one of my cameras.

I deliberately avoided bright colors in the photo in order to emphasize the beautiful skin tone.

I placed a 4x6-foot softbox to the left of the model and almost at floor level. The side lighting gave good modeling to the legs. The light source

54

Purpose: Test shot for a model
Camera: Hasselblad
Lens: 150mm
Lighting: Two electronic flash heads in 4x6-foot Chimera softbox; two electronic flash heads in 36-inch umbrellas and one in a pan reflector
Film: Ektachrome 64 (Daylight)
Exposure: Between *f*-16 and *f*-22

was large enough to avoid a shadow of the left leg on the right leg.

To get an even, white background, I flooded white, seamless paper with a flash from each side and a third flash at the center. ☐

55

Client: Home magazine, Los Angeles Times
Art Director: Al Beck
Camera: Nikon F2
Lens: 35mm
Lighting: One bare electronic flash and one electronic flash in 3x4-foot Chimera softbox
Film: Kodachrome 64
Exposure: *f*-22

This set was created by two show-room designers from a large department store. As background, they selected the clean, white wall of my studio, feeling that it was appropriate for the simple Oriental style they had in mind.

I used two light sources. The main light consisted of a 3x4-foot softbox, suspended a few feet above the bed and pointing down. It showed off the bed linen nicely and revealed detail on the tray. The second light, a bare flash head, was placed behind the rice-paper screen at the head of the bed. The screen, in effect, acted as a diffuser for the light.

I adjusted the power output of the light behind the screen until it gave the right lighting ratio with the main light. The bare flash also lit the area behind the bed, providing graphic separation between bed and wall.

To brighten the vertical bottom and side of the bed, I used two large, white reflector cards.

The main light and reflector cards were positioned sufficiently far from the bed to allow me to change image size and framing without having to rearrange the lighting. I took several other shots in addition to the two reproduced here. □

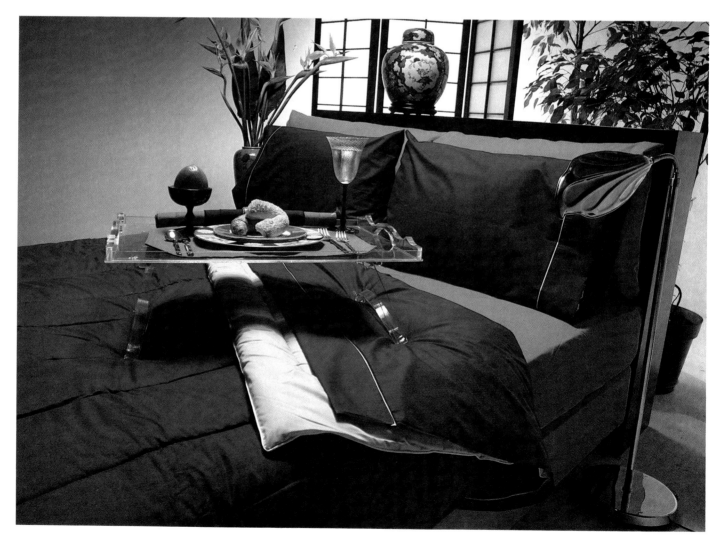

56

Client: Janeil
Ad Agency: Hamilton Advertising, Inc.
Art Director: Kim Blessington
Camera: Sinar-f 4x5
Lens: 250mm
Lighting: One electronic flash in 2x3-foot Chimera softbox; one electronic flash in cone reflector
Film: Ektachrome 64 (Daylight)
Filtration: Deep-blue gel on background light
Exposure: *f*-32

Modern electronic equipment is made in two distinct styles. There's the *user-friendly* style, in which light-toned plastic is generally dominant. Such equipment is often best photographed in a domestic setting—either in a real home or on a studio set.

The equipment shown here is of the second style, having a sophisticated *hi-tech* look. This state-of-the-art receiver for TV microwave satellite dishes consists of black metal and shiny, chrome controls. I like to photograph this kind of equipment in a semi-abstract, futuristic setting.

I placed the product on a highly reflective base. The reflection was about one exposure step darker than the object itself. Thus, the reflection added interest to the image without distracting attention from the subject. The reflection also helped to add depth to an otherwise flat composition.

Main lighting came from a 2x3-foot Chimera softbox, placed to the far right of the camera. It gave a pleasing luster to the front face of the unit and highlighted the chrome buttons nicely. Because there was no detail to show on the side of the unit, I allowed it to fall into silhouette against a spotlighted area on the black background.

The background light, a flash in cone reflector, had a deep-blue gel on it. This electric blue seemed appropriate for the product and contrasted nicely with the red lettering on the unit. The placement of the spotlight serves another purpose: it draws viewer attention to the manufacturer's name on the unit. □

This was a personal, experimental shot. In creative photography, experimentation is never wasted. I always learn something new and useful.

The set was very simple. The base was a white reflector card. The background was another such card. Lighting came from a high-intensity tungsten desk lamp. To get the light behind the glassware, and achieve the attractive frontal shadows, I had to tilt the background card back slightly.

To get the best basic color balance with the desk lamp, I used a tungsten-balanced film. I then added a deep blue filter to the camera lens to get the effect you see in the photo.

This shot illustrates well how shadows play an integral part in a composition. To establish graphic balance for the whole image, including shadows, I placed the objects toward the upper, right corner of the frame. I tilted the camera for dramatic effect.

Because the objects photographed were all transparent, no frontal fill light was needed. ☐

Purpose: Experimental photograph
Camera: Hasselblad
Lens: 80mm
Lighting: High-intensity tungsten desk lamp
Film: Ektachrome 160 (Tungsten)
Filtration: Wratten No. 47 (Blue)
Exposure: *f*-16 (shutter at 1/8 second)

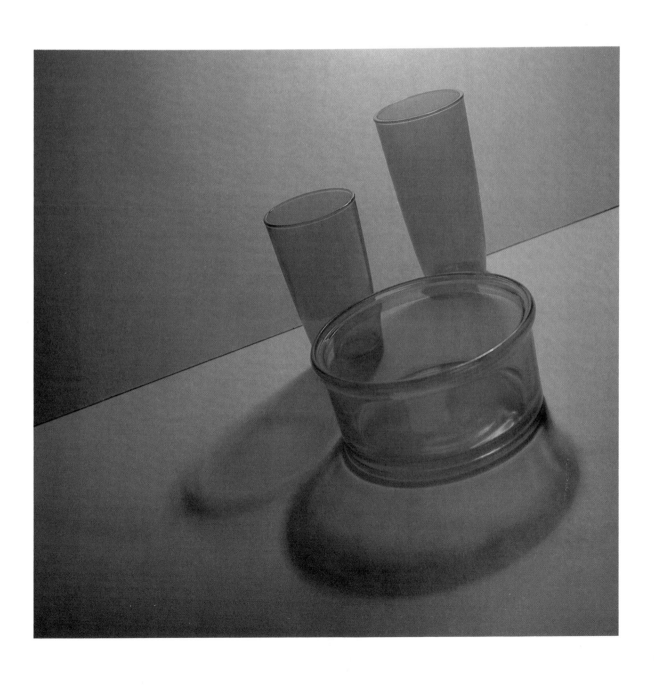

Client: American Commerce Exchange
Camera: Nikon F2
Lens: 50mm
Lighting: One electronic flash in 3x4-foot Chimera softbox; one electronic flash in cone reflector
Film: Kodachrome 25
Filtration: Green gel on background light
Exposure: *f*-22

Although United States paper money is commonly regarded as being green, the fact is that only the back side has mainly that color. We wanted to show the front, which is essentially black and white. My solution was to suggest green by adding some green lighting.

The purpose of this photo, made for the American Commerce Exchange, was to project the idea that, through barter, you could largely do away with the need for money.

I had discussed with the client the possibility of showing someone displaying his empty, inside-out pockets or of photographing the burning of money. Ultimately, we decided on the idea depicted here.

Although United States paper money is commonly regarded as being green, the fact is that only the back side has mainly that color. We wanted to show the front, which is essentially black and white. My solution was to suggest green by adding some green lighting.

The subject was basically two-dimensional. To introduce some apparent depth, I gave the green background light a spot effect. I aimed a flash, in cone reflector and with a green gel in front of it, at the lime-green seamless paper that formed the background.

The money and scissors were lit by a 3x4-foot softbox, placed to the right of the camera. It provided even illumination to the money and gave an attractive luster to the scissors.

The dark background clearly outlines the money and scissors. To ensure a clearly visible outline to the lower edges of the money, I made the background spotlight considerably brighter than those edges. □

Client: Home magazine, Los Angeles Times
Art Director: Al Beck
Camera: Nikon F2
Lens: 105mm
Lighting: Two electronic flash heads in cone reflectors
Film: Kodachrome 25
Exposure: *f*-22

I made this photo for an editorial feature on summer beverages. We needed a sunny, subtropical environment, right in my studio. We created a set with simple components—a bamboo screen, a palm-tree branch and some strong light. The wicker chair and fruit helped to emphasize the summery atmosphere.

The background behind the screen was a white wall. I directed a flash in a cone reflector at the wall. To simulate afternoon sunlight, I directed a second flash, in cone reflector, at the subject from just beside the bamboo screen. A white card reflector on the left side brightened the shadow side of the face.

To draw viewer attention to the subject's face and the drink, I held back some of the light to the lower part of the scene with a diffusing screen.

This photo suggests a setting with palm trees all around. Actually, all that was needed—or used—to create this effect was a single branch, cut from a palm tree near my studio. Another example of "less is more."

Professional photography can be much like show business. When an assignment has been booked, deadlines are to be met, art director, stylist, model and assistant are on the set, the show must go on. In this case, I had a temperature of 102F, but somehow I managed to perform! ☐

Client: The magazine Flowers &
Art Director: M. J. Cody
Camera: Nikon F2
Lens: 35mm
Lighting: One 2000-watt-second electronic flash in 4x6-foot Chimera softbox
Film: Kodachrome 64
Exposure: *f*-22 (shutter speed 1/2 second)

The purpose of this photo was to show floral Christmas displays. The attractive fireplace made an effective setting. This was a location shot. Shooting on location need be no more difficult than studio shooting, as long as you maintain control.

The main problem in making this shot was light control. First, the room in which the fireplace is located has large windows. To enable me to see the effect of my flash modeling lights, I had to black out the windows.

The second lighting problem was to balance various sources. In addition to the flash, there were the candelabra on the wall, the fire, and recessed lighting around the perimeter of the grate.

I had a single flash head in a 4x6-foot softbox. I placed the softbox high and to the left of the fireplace to reveal both the texture and gloss of the wood. The softbox also highlighted the floral displays. A white 4x8-foot card reflector to the right of the camera lightened the shadows.

The light source that was least controllable was the fire, so I based exposure time on this, having already determined the aperture setting for the flash. Having had the candelabra and the recessed lights put on dimmer switches, I controlled the brightness of each of them to also suit the exposure I had set. □

61

Purpose: Poster suitable for kitchen and dining area
Camera: Nikon F2
Lens: 50mm
Lighting: One 2000-watt-second electronic flash in 3x4-foot Chimera softbox
Film: Kodachrome 25
Exposure: *f*-32

Although photography is a creative art, involving feelings and sensitivities, rarely is a good photograph produced without a considerable amount of thought also. When I do something, I usually have a good reason for it.

The three images reproduced here represent experimentation in producing a poster suitable for display in a kitchen or dining area. There were four distinct things I wanted to achieve:

First, the image was to be symbolic rather than literal. I didn't want to show food, but simply to imply it.

Second, I aimed for simplicity. Only in this way could I satisfy the first need, namely symbolism. I chose as my subjects a white, plastic fork and a white plate, and nothing more.

Third, I intended to shoot the photo in high key. By eliminating form and shadows as much as possible, and relying on simple shapes, I could best satisfy the second need, that of simplicity.

Fourth, I intended to provide the prospective purchaser of my poster with some variations. Notice that I produced three very different compositions with the same two, simple props and identical lighting.

The subject was lit by a 3x4-foot softbox. I positioned it just behind the plate, with the far edge touching the table and near edge almost over the camera. No additional fill light was needed.

To keep the image as simple as possible, I resisted using a base with a luster, choosing instead the uniform white of seamless paper.

A simple image is not necessarily simple to shoot. When you have only a couple of image components, their placement and lighting are all the more crucial. □

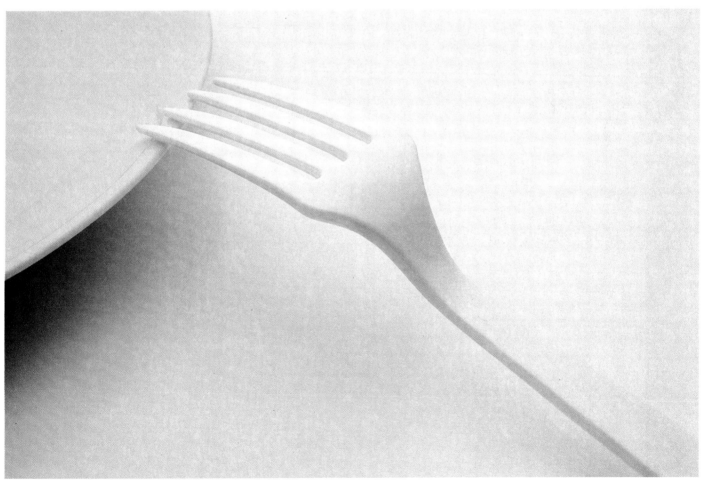

62

Client: Eesof
Ad Agency: Dimensions 3
Art Director: Mathew Ewald
Camera: Hasselblad
Lens: 120mm
Lighting: One 2000-watt-second electronic flash in 4x6-foot Chimera softbox
Film: Fujichrome 100 (Daylight)
Exposure: *f*-22

Computer manufacturers and advertisers provide a constant need for good photography of computer equipment. I know of several photographers who specialize exclusively in that area. Personally, I would rather be more diverse, both for esthetic satisfaction and economic security. However, I love assignments of this kind mixed in with my other work.

This photo was made for the cover of a trade magazine. My art director, Mathew Ewald, agreed to also be my model.

The office setting was created very easily and economically in my studio. The two desks—positioned in an approximate L-shape—were white, wooden doors. The background wall was a sheet of gray seamless paper.

I places the main-light Chimera softbox on the right side, almost behind the computer. From there, it provided the best lighting on the equipment, showed the white and red box and the various documents clearly, without reflections, and provided flattering illumination to the model.

To create the illusion of daylight coming through a window, I placed a gold-foil reflector behind the subject. Notice the warm glow on the back of his shirt.

I photographed the screen image separately and had it stripped into place later. That way, I didn't need to worry about avoiding reflections from the screen when making the main shot. □

Client: Home magazine, Los Angeles Times
Art Director: Al Beck
Camera: Nikon F2
Lens: 105mm
Lighting: One ring flash; two umbrella flashes; one tungsten spotlight
Film: Kodachrome 25
Exposure: *f*-22 (shutter speed 1/8 second)

This photo is one of a series I shot of ski outfits for editorial use in *Home* magazine. While I wanted to show the outfits clearly, I also wanted to introduce a little movement into the images to convey the excitement and vitality of skiing.

I placed one umbrella flash on each side of a sheet of white, seamless paper to create a pure white background. The general subject illumination came from a ring flash around the camera lens. It provided virtually shadowless illumination. The camera was mounted on a tripod. The flash provided the sharp image.

A tungsten spotlight was aimed at the subject's face and chest. Just before I exposed, I asked the subject to sway back and forth without moving the skis he was holding. With a shutter speed of 1/8 second, I was able to record his movement as a blur. To determine the best shutter speed, I had made a few preliminary test exposures on Polaroid film. □

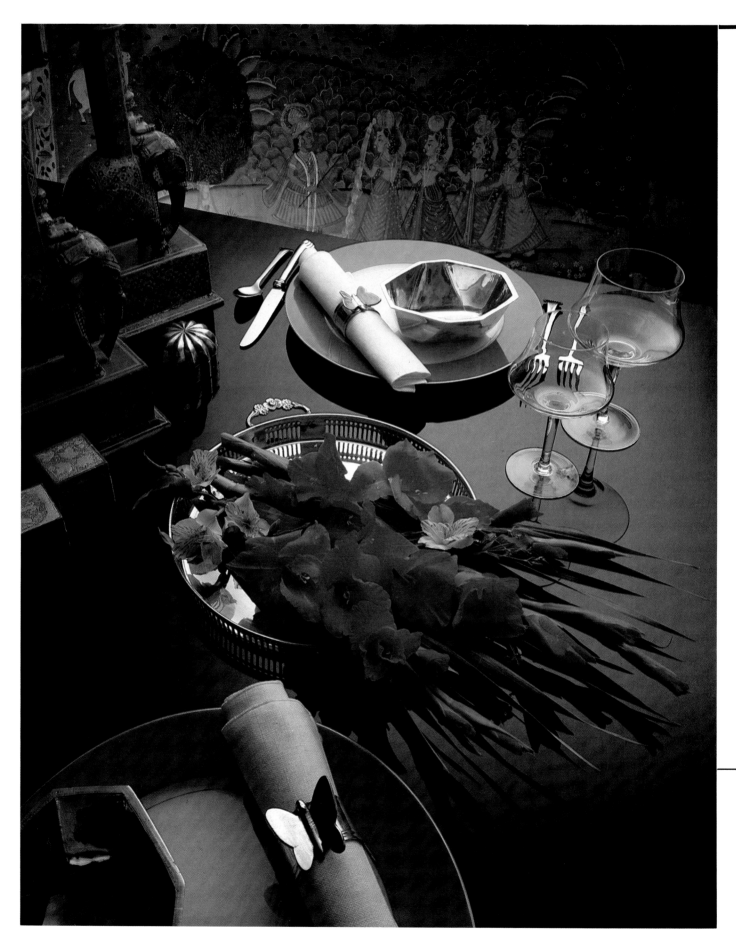

Client: Designers West magazine
Art Director: Vivian Blanchard
Camera: Sinar-f 4x5
Lens: 90mm
Lighting: One electronic flash in cone reflector, behind large diffusing screen; one electronic flash in pan reflector
Film: Ektachrome 64 (Daylight)
Exposure: *f*-45

The background light was below the table and pointed directly at the Indian tapestry. I deliberately lit the lower part of the tapestry more brightly than the top to retain viewer attention in the picture.

This photo was part of a magazine feature on the preparation of an Indian dinner. I had shot a series of photos showing the preparation of the food. This picture was intended to show an appropriate table setting for the meal.

Just as I would probably use high-key lighting for a Scandinavian scene, I felt that a heavy, low-key treatment would be more effective in bringing out the rich, hearty feeling often associated with Indian cooking.

The main light was a flash in a cone reflector, placed behind, and close to, a large diffusing screen. By placing the light close to the screen, I could control the placement of distinct highlights. Notice how the light helps to emphasize the rear plate and produces a bright patch on the plexiglass base in that area.

To introduce some brightness in the foreground area, I carefully positioned the napkin ring so that one of the butterfly wings was highlighted.

The background light was placed below the table and pointed directly at the Indian tapestry. I deliberately lit the lower part of the tapestry more brightly than the top to retain viewer attention in the picture.

The plexiglass base gave clean, sharp reflections that resembled shadows. With the soft lighting I was using, it would not have been possible to achieve actual shadows of such clarity.

To exaggerate the perspective, I shot from close to the set, using a short, 90mm lens. ☐

Purpose: Composite photo for a magazine cover
Ad Agency: Media Design West, Inc.
Art Director: Dave Mangoni
Camera: Nikon F2
Lens: 50mm
Lighting: One 2000-watt-second electronic flash in 4x6-foot Chimera softbox; one electronic flash in a small umbrella
Film: Ektachrome 64 (Daylight)
Exposure: f-32

This photograph was made for the cover of a magazine. Actually, it isn't a single photograph, but a combination of several photos and some graphics. It's a good example of creative composite photography.

The male model and foreground telephone were lit by a 4x6-foot softbox to the right of the camera. Hair lighting was provided by a flash in a small umbrella. Traditionally, spotlights are used for hair lighting. However, I prefer the more subtle effect yielded by a softer light.

The computer terminal in the background was shot on a separate sheet of film. Main lighting came from a softbox placed above and slightly to the rear of the unit. Two white reflector cards were placed very close to the sides of the unit.

A third photo featured nothing but the terminal's screen image. By shooting it separately, I could easily bracket exposures for both the terminal and the screen image and then use the best of each. The screen image was later stripped into its proper location on the unit.

After the three photographic components were carefully stripped into position against a black background, some graphics were added. They consisted of the lines leading from the foreground to the screen and the circles behind the screen. Starlight spots were also added to the background. □

I had been shooting a series of pictures of sponge cakes for *Home* magazine, the Sunday supplement to *The Los Angeles Times*. My stylist had found some Oriental basket steamers and thought they would make attractive storage containers for the cakes.

I had a sheet of textured glass which had been lying around my studio for some time and which I thought would make an ideal background for this shot.

After composing the still-life, I placed a 3x4-foot softbox over the baskets and slightly to their rear. This light provided beautiful modeling to the baskets and brought out their texture well. To get a light patch of the right size around the baskets, I had chosen carefully the size of the softbox and its distance from the subject.

To partially brighten the frontal shadows, I placed a small mirror to the right of the camera. It directed some of the main light onto the right sides of the two baskets in the front. I deliberately avoided placing the mirror in front of the camera. This would have "killed" the frontal shadows altogether and deprived the baskets of their rounded appearance in the photo. ☐

Client: Home magazine, Los Angeles Times
Art Director: Al Beck
Camera: Nikon F2
Lens: 35mm
Lighting: One electronic flash in a 3x4-foot Chimera softbox
Film: Kodachrome 64
Exposure: Between *f*-22 and *f*-32

67

Purpose: Experimental photograph
Camera: Nikon F2
Lens: 105mm
Lighting: One 2000-watt-second electronic flash in a 3x4-foot Chimera softbox
Film: Kodachrome 25
Filtration: Opposite page—deep magenta filter
Exposure: This page—*f*-22; opposite page—*f*-16

I had purchased some geometric shapes for demonstrating lighting technique. These props had lain around my studio for weeks. Occasionally, I would place them under my desk lamp and examine the different lighting effects I could achieve by simply moving them around. Eventually, I used them for some experimental photos, of which these are just two examples.

To give these simple objects an imposing appearance, I shot from a low angle. I bounced enough light into the lower side of the black plexiglass strip on which they were standing to separate the strip from the dark background.

The main light was a 3x4-foot softbox, placed to the left of the objects. In addition to giving attractive modeling to the balls and cone, this light also produced a nice rim light on the plexiglass strip.

To provide a clean separation between the shaded side of the white ball

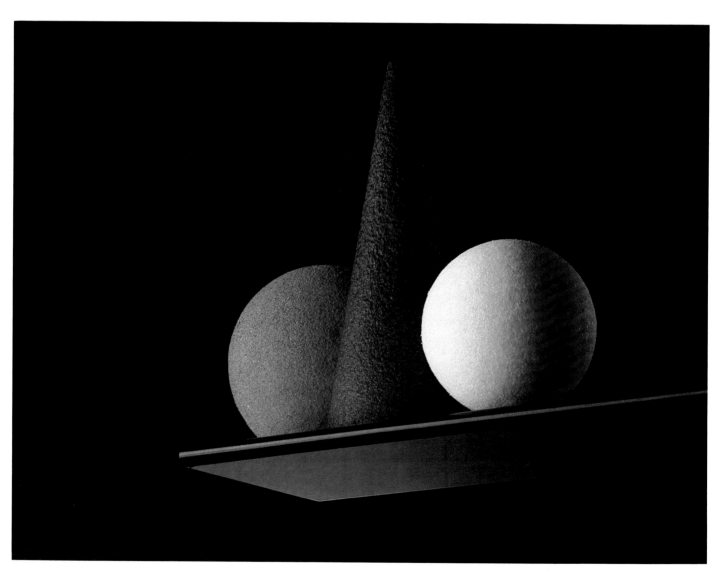

and the dark background, I added some rim light to that ball. I did this with a small mirror, placed to the right of the ball and just behind it.

Throughout the composition, notice how highlight and shadow areas overlap to provide maximum separation between the objects.

The only difference between these two images is the color. The photo on this page was shot through a deep-magenta filter. □

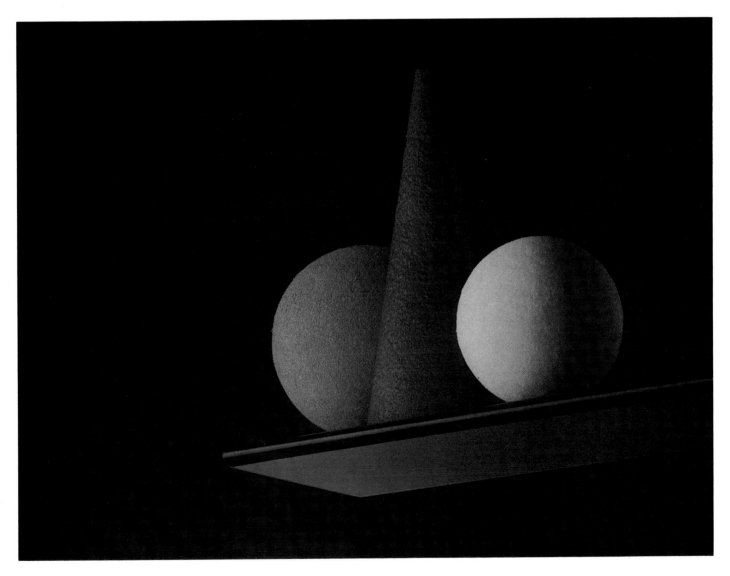

68

Client: Duty-Free Shoppers
Art Director: Linda Katsuda
Camera: Sinar-f 4x5
Lens: 90mm
Lighting: One 2000-watt-second electronic flash in 4x6-foot Chimera softbox
Film: Ektachrome 64 (Daylight)
Exposure: *f*-32

To emphasize the unusual tubular form of these perfume bottles, their ornate stoppers and bright, yellow labels, I decided to crop the image so that the bottle bases and any foreground were omitted. To add prominence to the product, I shot from a low angle.

Only one light was required. It was a softbox that formed the background. This source transilluminated the perfume, yet gave the bottles a clear outline. It also provided beautiful modeling to the glass stoppers. Because the bottles were transparent, the inscribed lettering was clearly legible by back lighting.

Had the labels been opaque, or the bottles themselves less transparent, I would have needed some frontal light, either from a separate source or—more likely—from a reflector card.

To make both stoppers fully visible in the image, I placed the shorter bottle in front of the taller one. Even without this particular requirement, however, it is generally better compositionally to have the smaller of two objects nearer the camera. □

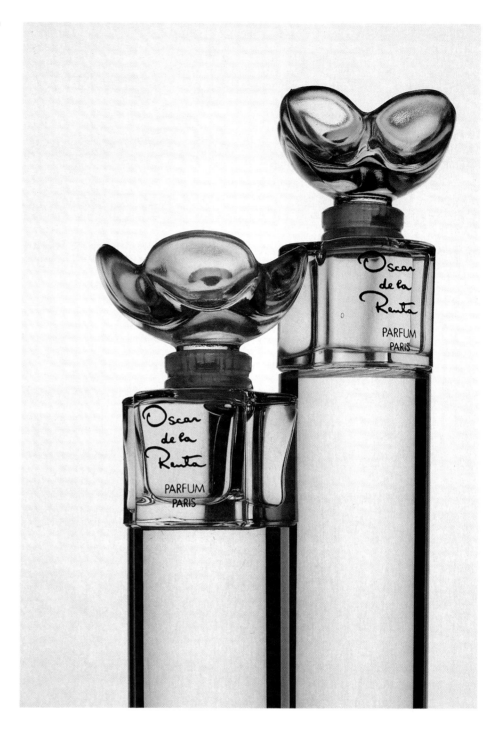

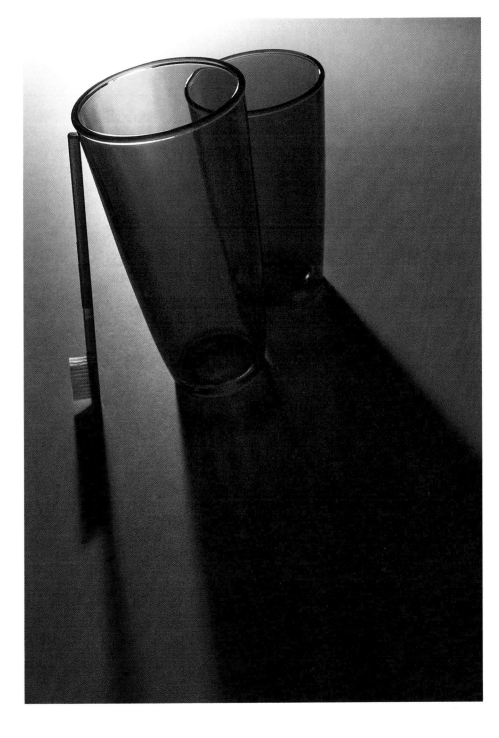

Purpose: Experimental photograph
Camera: Nikon F2
Lens: 50mm
Lighting: One 2000-watt-second bare flash head
Film: Kodachrome 25
Exposure: Between *f*-16 and *f*-22

Many photographers cringe at the very thought of photographing glass. They seem to think that reflected light is the only light that can be controlled.

I get enormous joy from the challenge of recording the translucency, transparency, texture, color as well as the reflective qualities of glass.

More than any other kind of object, it's essential that you really examine glassware before you photograph it. Determine what its inherent qualities are. Then decide how you can best bring them out in a photo. Your most effective tool is usually the lighting.

When I'm experimenting, I often try things that are totally opposed to my normal manner of operation. As you know by now, my usual light form is soft and diffused. Here, I used a hard, point-source of light in the form of a bare flash tube. It generated deep, sharp shadows.

The flash was behind the glasses and a little to the left. Notice how the shadows of the glasses and the red toothbrush form an integral part of the composition.

No frontal fill light was needed. Had there been a label on the glass, however, I would have needed some frontal light to make it legible.

Notice the subtle difference between this image and portfolio number 57. Both are dominantly blue. However, photo number 57 is *totally* blue while the one on this page contains a small element of red. Had I used a deep-blue No. 47 filter for the image on this page, the red toothbrush would have gone black and the image would have been a monochromatic blue. ☐

Subject: Cassandra Gava
Camera: Nikon F2
Lens: 105mm
Lighting: One 2000-watt-second electronic flash in seven-foot umbrella
Film: Kodachrome 64
Exposure: *f*-16

Black is popular for glamour photographs because it directs the viewer's full attention to the form, skin tone and soft lines of the model. I went one step further than having Cassandra wear black—I shot her in front of a black background.

This photograph, like portfolio number 25, was made for two portfolios—mine and that of Cassandra Gava, a successful actress and model. Cassandra provided me with her beauty and modeling skills and I repaid her with a series of photographs. This kind of barter is common among photographers and models.

To get soft lighting that did justice to Cassandra's fine features and smooth skin, I used a flash in an umbrella seven feet in diameter. It literally wrapped her in light. I placed the light off to the left of the camera. To lighten shadow areas on the right, I placed a large silver-foil reflector on that side.

Black is popular for glamour photographs because it directs the viewers full attention to the form, skin tone and soft lines of the model. I went one step further than having Cassandra wear black—I shot her in front of a black background.

Notice that I filled the image with my subject. Compare this with the other photo of Cassandra, portfolio number 25. In that image, I left plenty of empty space above her. That's because she was bending over. Cropping tight in such a pose would give a cramped impression. ☐

Client: Home magazine, Los Angeles Times
Art Director: Al Beck
Camera: Sinar-f 4x5
Lens: 90mm
Lighting: Two electronic flash heads in a 4x6-foot Chimera softbox
Film: Ektachrome 64 (Daylight)
Exposure: Between *f*-22 and *f*-32

This photo is one of a series I shot for a magazine feature on low-calorie meals. An ostentatious table setting would have been inappropriate. On the other hand, I didn't want a setting of extreme austerity either. The arrangement shown here seemed a good compromise.

Soft top lighting, slightly to the rear of the set, provided a pleasing glow to the table surface, plates, silverware and glasses. The warm, monochromatic color scheme was intentional.

I had to water down the wine to make it look attractive in the photo. The silver tray reflected light through the wine in the two glasses on the tray. To give the wine in the third glass some glow, I placed a small foil reflector behind the glass.

In composing this photo, I had to bear in mind a couple of editorial requirements. First, I had to leave some space in the left foreground for the addition of copy. Second, I had to leave a space between the plate on the right side and the other two plates. That was because the photo was intended for a two-page spread and I had to avoid placing important image information in the "gutter" area that separated the pages.

Every day, we see photographs of food—in magazines, advertisements, cookbooks and on TV. Rarely does the general public give thought to the tremendous amount of work involved in making these images. Photography is only a part of it. There's the cooking, styling and set preparation. To make the photo reproduced here, I had with me in the studio an art director, food editor, general stylist and food stylist.

Constant care must be taken that food that's placed before the camera fresh actually appears fresh in a photo. For example, the bananas in this photo would have rapidly turned dark-brown, had we not coated them with lemon juice. Apples and some other fruits and vegetables can be temporar-ily "preserved" in the same way.

If the setup is complicated and takes a considerable time to prepare, it's sometimes advisable to use stand-in food during the preparatory stage. Only when everything is ready is the real, fresh food brought onto the set.

We selected a stainless-steel table surface to complement the metal containers. Lighting came from a large softbox, placed above and slightly to the rear of the set. It provided clean highlights to the metal surfaces and gave attractive frontal shadows.

To provide the dark upper background, I shielded the light in that area with a black card. The empty foreground area was needed for the later addition of copy. □

Client: Home magazine, Los Angeles Times
Art Director: Al Beck
Camera: Sinar-f 4x5
Lens: 90mm
Lighting: Two electronic flash heads in a 4x6-foot Chimera softbox
Film: Ektachrome 64 (Daylight)
Exposure: ƒ-45

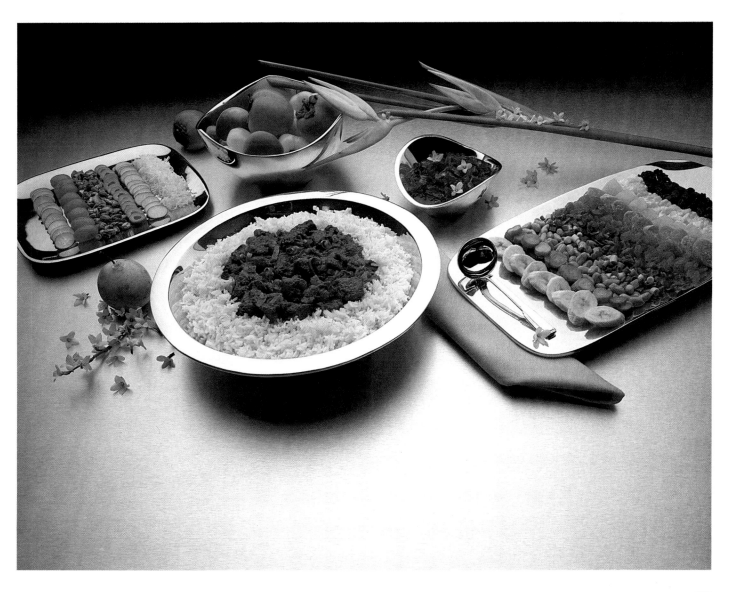

Client: The magazine Flowers &
Art Director: M.J. Cody
Camera: Nikon F2
Lens: 35mm
Lighting: One electronic flash in a
3x4-foot Chimera softbox
Film: Kodachrome 64
Exposure: *f*-11

Valentine's Day is one of the busiest days in the year for florists. This photo was part of an editorial feature for *Flowers &* magazine on floral arrangements for Valentine's Day.

Seasonal photos, whether for Christmas, Mother's Day or Valentine's Day, usually must be shot well in advance. The photo reproduced here, for example, was made in September—about five months before the festive day. When shooting out of season, it's sometimes difficult to get the necessary props. For example, to find the right flowers in late fall may require searching specialty markets or even ordering from another country.

Red is probably the most romantic of all colors. For this reason, we wanted to make red the theme color. We added a generous amount of white to produce a bright, cheerful image.

Because the lace tablecloth appeared a little "busy," I used a wide lens aperture to record the background out of focus. This way, it distracted less attention from the main subject.

To create a high-key image, I lit the subject from above with a large softbox and added several shadow-filling reflectors at the sides.

Because flowers are most often bought as gifts, they are particularly attractive to a customer when they come with something durable. The flower display shown here is in a vase in the form of an airplane. The recipient can use the vase over and over again, long after the original flowers have died.

Client: The magazine Flowers &
Art Director: M.J. Cody
Camera: Nikon F2
Lens: 50mm
Lighting: Two electronic flash heads in a 4x6-foot Chimera softbox
Film: Kodachrome 64
Exposure: *f*-22

The most elaborate floral displays for homes and public places alike are found at Christmas time. The photo reproduced on this page shows a window arrangement that I had photographed for *Flowers* & magazine. This magazine regularly shows displays designed and made by florists all over the world. The display shown here features an unusual Christmas tree— made from flowers and musical instruments.

Portfolio number 22 shows two images of works of sculpture. In the text accompanying them I explained that, in such a situation, a photographer must take a creative "back seat" to the artist who created the object depicted. This floral display presented a similar situation.

It was important for me to show what the artist had created without injecting too much of my own artistry. My creativity had to be subordinated to that of the floral artist. My job was to make a good record.

To bring out the best in the floral creation, I chose a dark background and a reflective base. A subtle red glow on the background complemented and enhanced the red in the subject. To make the display look tall and elegant, I shot from a low angle.

Lighting came from a large softbox to the left of the camera and a large, white reflector card to the camera's right side. I took great care to avoid reflections of dark objects around the studio in the shiny trumpet. □

Client: Duty-Free Shoppers
Art Director: Linda Katsuda
Camera: Sinar-f 4x5
Lens: 250mm
Lighting: One electronic flash in a 2x3-foot Chimera softbox; one electronic flash in pan reflector
Film: Ektachrome 64 (Daylight)
Filtration: Deep-blue gel on background light
Exposure: *f*-32

The simpler the subject, the more creative must a photographer be to produce an eye-catching image. In creating the image reproduced here, my main tools were the use of angles, color and highlights.

By placing the bottle on a slightly angled ledge, viewer attention is drawn directly to it. The ledge is emphasized by a bright highlight along its frontal edge. To make the bottle appear as prominent as possible, I shot from a low angle.

The blue spot of light on the background serves to make the bottle stand out. The background itself was blue seamless paper. To make it glow, I used a blue gel on the background light—a flash in pan reflector. I chose blue for the background spot because it contrasted well with the red bottle cap.

Subject illumination came from just one softbox, placed to the left of the camera. The front of the bottle was highlighted just enough to give it form but not so much as to "kill" the gold lettering.

The simpler the subject, the more creative must a photographer be to produce an eye-catching image. In creating the image reproduced here, my main tools were the use of angles, color and highlights.

Notice that, although this image has a lot of empty or "negative" space, the composition is such that viewer attention is immediately drawn to the bottle. □

Purpose: Test shot for promotional photo
Camera: Nikon F2
Lens: 35mm
Lighting: One 2000-watt-second electronic flash behind 6x6-foot diffusing screen
Film: Kodachrome 64
Exposure: ƒ-22

In this experimental photo, I tried to make a satirical statement. The gun looked very real and threatening. However, the harmless caps revealed the truth: the gun was a toy!

As you'll be aware by now, I often use plexiglass as a background. Perhaps one reason is because I generally use soft lighting that doesn't yield sharp shadows. The crisp reflections given by plexiglass can be a good substitute for missing but desirable shadow effects.

The light source was a single flash head, placed about 18 inches behind a 6x6-foot diffuser. The closeness of the flash to the diffuser ensured a little directional light in addition to the general, diffused illumination. I wouldn't have been able to achieve the distinct tonal gradation in the plexiglass with the uniform light surface of a softbox.

To fill shadows, I used a white reflector card to the right side of the camera.

Compositionally, notice the tonal separation between the gun barrel and its reflection. Also, notice the dominance of the red cap rolls, which have no other colors to compete with for attention. Because the bright parts of the cap rolls are set against the dark reflection of the gun, the rolls stand out even better. □

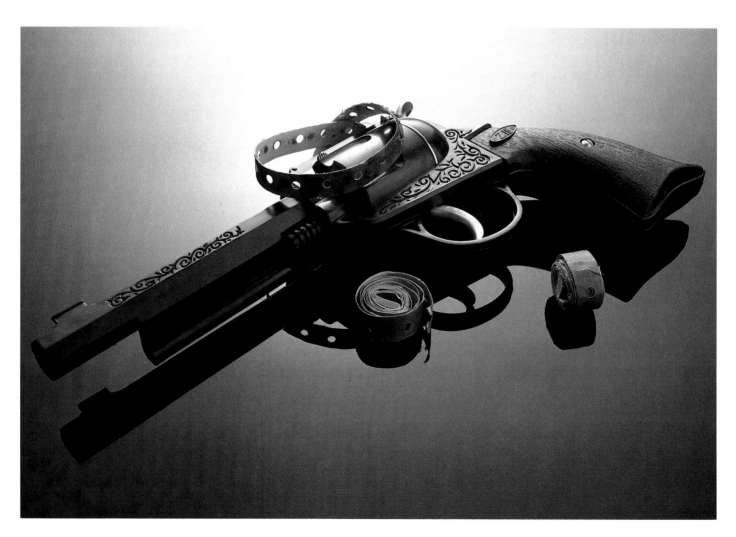

Many clients tend to shy away from monochromatic color photos. They believe that, because they are paying for color photography, they should get color—a lot of it, in many hues and shades.

Sometimes the monochromatic treatment is much more effective. This photo is a good example. It shows chocolate letters made by Krons. The most effective way to "depict" the chocolate "flavor" graphically was to keep the colors within the chocolate-brown range.

Don't ever add anything to a picture that doesn't contribute to its impact. In this example, more color would have been superfluous and would have weakened the image.

The background consisted of brown seamless paper under an 1/8-inch thick sheet of plexiglass. The combination provided a brown background with a pleasing luster.

I placed a 6x6-foot diffusing screen above the subject and slightly to its rear. A flash head was placed about 12 inches above the center of this screen. The resulting light was sufficiently directional to give some tonal gradation to the background area.

The back lighting gave an attractive shine to the tops of the letters and also provided frontal shadows that made the letters look solid.

The dark reflection of the subject in the plexiglass graphically thickened the subject, which was rather thin. To exaggerate perspective and make the subject appear large and imposing, I shot from a close viewpoint, using a wide-angle lens. □

Client: Home magazine, Los Angeles Times
Art Director: Al Beck
Camera: Nikon F2
Lens: 35mm
Lighting: One 2000-watt-second electronic flash behind 6x6-foot diffuser
Film: Kodachrome 64
Exposure: Between *f*-22 and *f*-32

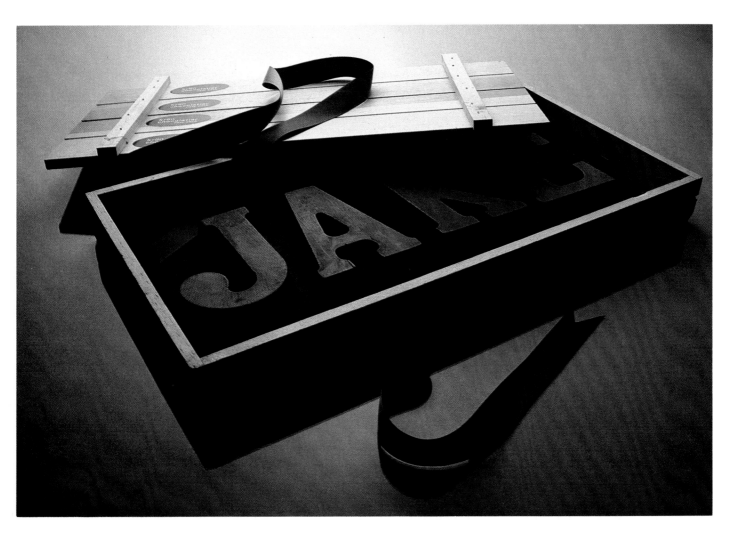

78

Client: The magazine Flowers &
Art Director: M.J. Cody
Camera: Nikon F2
Lens: 50mm
Lighting: One electronic flash in 4x6-foot Chimera softbox; one electronic flash in cone reflector
Film: Kodachrome 64
Exposure: f-22

Floral designer Mike Talamantez designed this fall window display for reproduction in *Flowers &* magazine. To enhance the feeling of fall and harvest time, the display includes fresh vegetables.

To maintain the fall atmosphere, art director M.J. Cody and I chose a rustic, brown color scheme. By selecting a background of medium tone, we could easily vary the background brightness by adding or removing light.

Notice the open space in the composition, just slightly to the left of center. This space was left deliberately so the picture could run across two pages without any important detail being lost in the gutter separating the pages.

The main light, a 4x6-foot softbox, was to the left of the set. The side lighting gave good modeling to the vases. A flash in cone reflector was aimed at the background behind the vases on the right side. To brighten the shadows of the vases on the right, I placed a white reflector card on that side, just beyond the camera's view.

Notice that I placed the eggs to the right side, farthest away from the main light. Being white, it was important not to overilluminate them and burn out their form. ☐

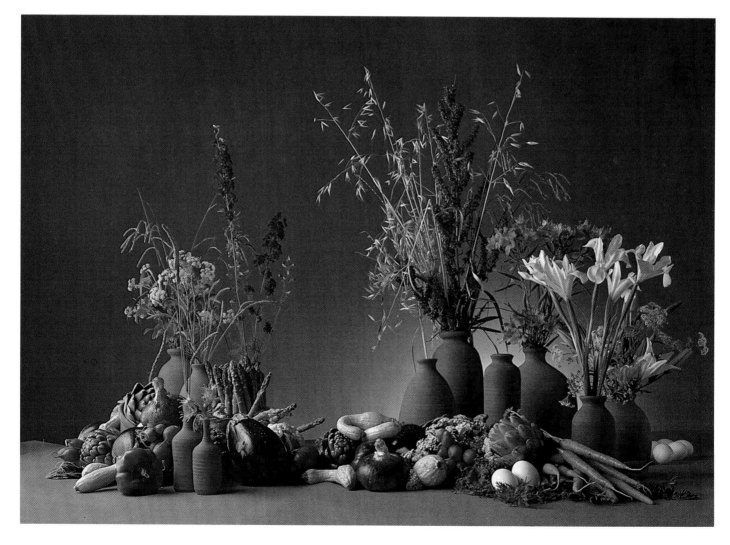

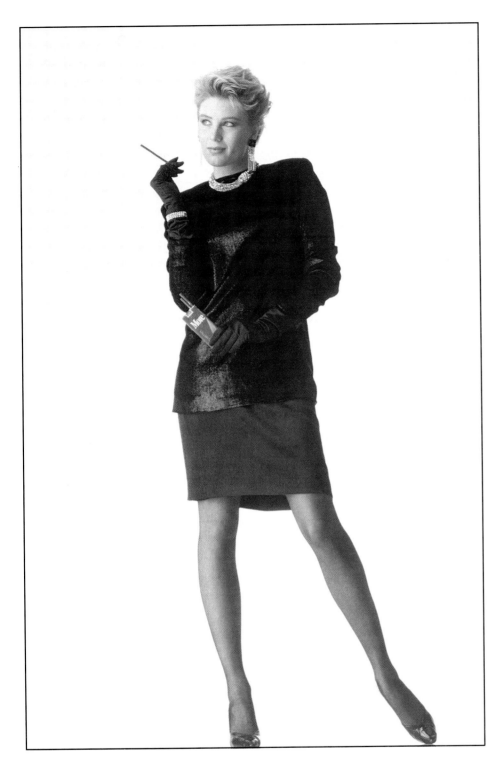

Purpose: Test shot for a model
Camera: Nikon F2
Lens: 105mm
Lighting: One electronic flash head in each of two 4x6-foot Chimera softboxes; one electronic flash head in each of three 36-inch umbrellas
Film: Ektachrome 64 (Daylight)
Exposure: f-16

I wanted to make this test shot of model and actress Tawny Moyer to appear like an ad. That way, it would be useful for her portfolio. Photography that sells a relatively small product often relies on fashion and glamour for eye appeal. I used that approach in making this photo.

However, I also had to be careful to give sufficient prominence to the product—a brand of cigarettes. I did this in several ways. First, I made the red pack stand out by locating it in front of the dark clothing. Second, I had Tawny hold one cigarette against the plain background, where it would be clearly visible.

To further emphasize the product, I had Tawny point the packet and the single cigarette in the same direction and asked her to look in that direction, too.

The white, seamless background was lit by three umbrella flashes—one on each side and a third below the table on which Tawny was standing. The main light on Tawny consisted of two 4x6-foot softboxes placed side by side. This gave an 8x6-foot light source, resulting in very soft illumination.

Because Tawny had mentioned that she believes that she looks best in very soft lighting, I added a large, white reflector card on the right side to lighten the shaded side of her face.

To enhance Tawny's elegant appearance, I shot from a low angle. To enable me to do this comfortably, I asked her to stand on a table. This had a secondary advantage: it made it easy to conceal the central background light. □

Client: Toshiba
Ad Agency: Abert, Newhoff & Burr
Art Director: Bob Hendricks
Camera: Sinar-f 4x5
Lens: 150mm
Lighting: One electronic flash in 4x6-foot Chimera softbox; two electronic flash heads in a strip light
Film: Ektachrome 64 (Daylight)
Filtration: Deep-blue gel on strip light
Exposure: *f*-32

To suggest "electronics" in this photo of telecommunications equipment, I used an electric blue color in the background. The blue strip also suggests a distant blue sky—an appropriate symbolism for long-distance communications.

Telecommunications is a growing field, calling for a lot of promotional and advertising photography. This photo, made for a brochure on Toshiba business phones, is a typical example.

To emphasize the state-of-the-art technology, we wanted a slick, futuristic setting. A simple rubber floor mat with parallel ridges formed the impressive base for the equipment.

To suggest "electronics," I used an electric blue color in the background. The blue strip also suggests a distant blue sky—an appropriate symbolism for long-distance communications.

Main illumination came from a large softbox, placed above and slightly to the rear of the phone equipment. It gave a beautiful luster to the equipment and, at the same time, provided some distinct frontal shadows.

I placed a long, narrow strip light—covered by a deep-blue gel—below the rear edge of the rubber mat. It provided the blue strip on the otherwise dark background.

Although this is an attractive photo, on close examination you'll see some blemishes on the equipment. That's because it was a one-of-a-kind prototype that had suffered some rough handling. There wasn't time to have the damage repaired, so we did the next-best thing: we had retouching done on the transparency that was selected for use. ☐

81

Client: Home magazine, Los Angeles Times
Art Director: Al Beck
Camera: Nikon F2
Lens: 105mm
Lighting: One electronic flash in 3x4-foot Chimera softbox; one electronic flash in cone reflector
Film: Kodachrome 64
Exposure: f-22

To illustrate an article on growing melons in your home garden, I wanted to show an abundance of melons in a variation of the famous cornucopia. I felt that a wheelbarrow would be an effective "cornucopia" for this purpose.

I wanted to play down the presence of the wheelbarrow so that full attention could be concentrated on the melons. This was achieved by putting the wheelbarrow in silhouette so that only its graphic outline was visible. By eliminating distracting detail, silhouettes can be very effective. Perhaps that's why sunsets and sunset photos are so popular.

To enable me to put the background light below the level of the subject, I placed the wheelbarrow on my sturdy rolling table. The background was a dark-gray seamless paper. A flash head in a cone reflector, aimed from almost floor level, produced the subtle background lighting.

A 3x4-foot softbox, suspended from a boom arm, was aimed straight down at the melons. It gave them form and clearly separated them from the dark background. I was careful to limit the illumination on the wheelbarrow itself to the subtle rim lighting.

I used a 105mm lens and shot from an accordingly long distance to achieve a strong two-dimensional, graphic effect. □

This photo was made for the same article as the one on the previous page, on growing melons in a home garden. I had taken numerous close-up shots of individual melons and needed a key shot that basically said "home melon growing" in general.

Usually, seasonal foods are photographed when they are at their best, even if the photos are not to be used for months or a year ahead. The photos shot for this assignment, however, were needed urgently in the fall and had to be shot at that time. It was late in the growing season and the melons were not at their best.

This created one of those typical situations where a photographer has to draw on his reserves of resourcefulness as well as compromise. By subject selection, placement and lighting, I did the best I could.

To concentrate viewer attention on the melons, I chose a neutral studio setting. Shooting on location might have introduced too many distracting elements. I selected black lusterboard for a simple background.

Lighting came from a single flash head, placed about 12 inches behind a large diffusing screen. The diffusing screen was placed above and slightly to the rear of the melons. The close proximity of the light to the screen gave a combination of directional light and general, soft light.

The garden hose and trowel occupy about one-third of the picture area and yet are not intrusive. On the contrary, they are positioned to lead viewer attention to the melons. That's the art of good composition. □

Client: Home magazine, Los Angeles Times
Art Director: Al Beck
Camera: Nikon F2
Lens: 35mm
Lighting: One 2000-watt-second electronic flash behind 6x6-foot diffuser
Film: Kodachrome 64
Exposure: *f*-22

Client: Home magazine, Los Angeles Times
Art Director: Al Beck
Camera: Nikon F2
Lens: 35mm
Lighting: One 2000-watt-second electronic flash in 36-inch umbrella
Film: Kodachrome 64
Exposure: Between *f*-22 and *f*-32

I placed the skis on black plexiglass. It yielded the beautiful, dark reflections. Don't confuse these reflections with shadows. Plexiglass eliminates most shadows.

The snow was the plastic variety, available from most large window-display supply stores. To make the snow appear even more realistic, I applied a misting of water to it.

The soft main light came from a high position, behind the skis. The source was an umbrella flash in front of which I had placed a 6x6-foot diffuser or scrim. The soft light enabled me to record some detail in the snow and yet prevent the plexiglass from going totally black.

To create a pleasing composition and also to provide a feeling of perspective, I splayed the skis out at the front. To exaggerate perspective further and make the skis look longer, I shot from close to the skis, using a 35mm wide-angle lens.

Notice how the reflections of the ski tips form an integral part of the composition. Without the reflections, the skis would have had to occupy more of the image space. □

Client: Playgirl magazine
Art Director: Jim Chada
Camera: Nikon F2
Lens: 50mm
Lighting: One 2000-watt-second electronic flash
Film: Kodachrome 25
Exposure: *f*-22

I had been asked to make a series of seven or eight photos of sporting equipment. I had about 24 hours to deliver the job. However, I had no idea what the equipment was to be until it was delivered at my studio. Therefore, I had no idea what lighting or backgrounds I might need. The usual professional photographer's resourcefulness was called for!

When I saw the equipment, which included shiny, black swim fins and a knife, I knew I would need soft lighting that would produce large reflections rather than specular highlights.

After positioning the equipment on a sheet of black lusterboard, I placed a 6x6-foot diffuser above and behind the items. I used one flash head behind the diffuser, placing it close enough to the diffuser to give the light some direction. The lighting produced beautiful highlights and detail. It enabled me to record detail throughout the composition, from the dark fins to the knife blade.

You'll notice that the shiny background material is brightest at the back, where the light was closest to the diffuser. To graphically separate the equipment from the background, I located the dark items, including the fins, against the lighter part of the background. The bright knife blade, on the other hand, projected into the darker part of the background.

Because deep orange was the only color in the composition, I felt it important to record it as vitally as possible. I shot on Kodachrome 25, which provides excellent overall color rendition and is particularly good with reds and other warm colors. □

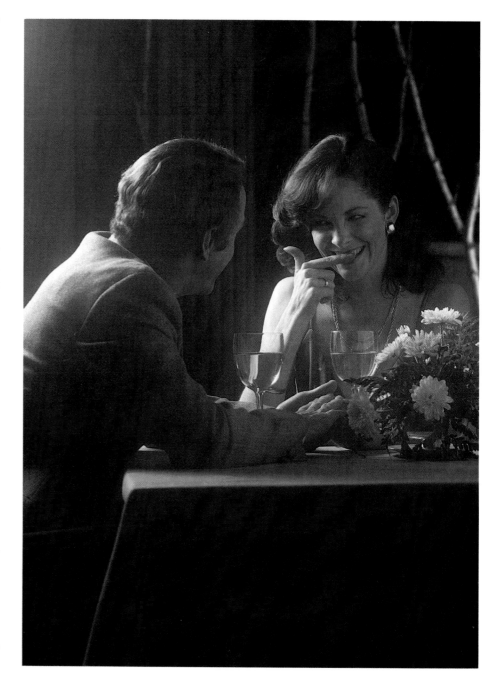

85

Location: Bernard's Restaurant, Los Angeles
Ad Agency: John Follis Design
Art Director: Deenie Yudell
Camera: Nikon F2
Lens: 105mm
Lighting: One 2000-watt-second electronic flash in 36-inch umbrella; one flash in cone reflector
Film: Kodachrome 64
Exposure: Between *f*-16 and *f*-22

The photos on these two pages were shot for a brochure designed to attract investors to a Los Angeles condominium project. One of the purposes of the brochure was to show what made the condos and their environment particularly attractive and desirable.

I shot at Bernard's, an elegant restaurant in a Los Angeles hotel. We were able to use the restaurant space early in the morning, before the regular business day started. Early in the morning, in an empty restaurant, it was difficult to create the atmosphere of a romantic evening meal. I achieved it largely by tight cropping, eliminating bare background areas.

A large umbrella flash to the left of the camera was so placed that it lit the woman's face and rim lighted the man's head and back. A white reflector card to the right of the camera lit the shadow areas, bringing some detail into the man's face and the unlit side of the woman's face. A second flash head, in a cone reflector, provided subdued background lighting.

To get a variety of shots, I changed camera angle and distance and shot some frames horizontally and others vertically. I also encouraged my models to have an animated conversation, so that I would get a variety of expressions and moods. □

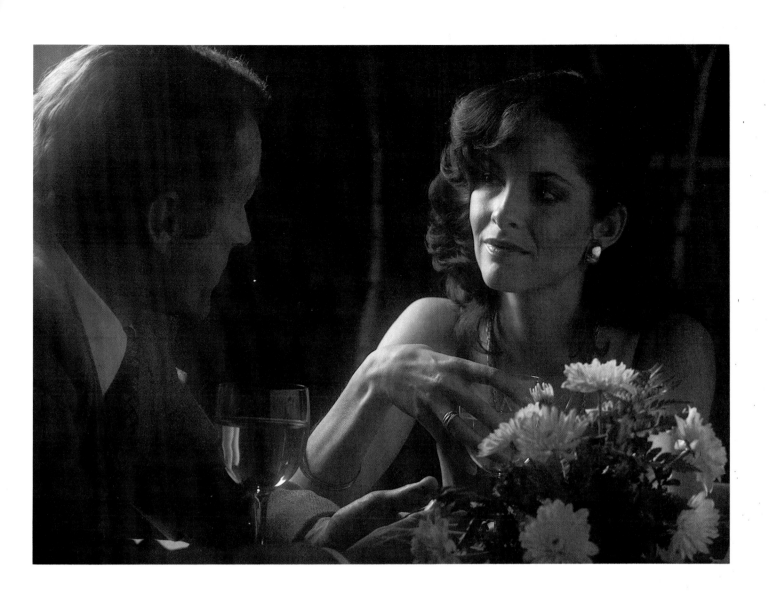

Client: Toshiba
Ad Agency: Abert, Newhoff & Burr
Art Director: Bob Hendricks
Camera: Hasselblad
Lens: 80mm
Lighting: One electronic flash in pan reflector
Film: Ektachrome 64 (Daylight)
Exposure: *f*-11 (shutter speed 2 seconds)

The flash exposure was calculated to be f-11. At that aperture, I needed to give an exposure time of 2 seconds for the screen image. To avoid image blur due to possible movement by the model, I made the exposure with all lights—including the flash modeling light—turned off.

This is a typical example of using a slick, futuristic setting to illustrate the use of state-of-the-art electronic equipment. More is suggested here than is actually seen: it's another good example of "less being more."

The background consisted of a black venetian blind, behind which was white seamless paper illuminated by a single flash in pan reflector.

The "desk" was a sheet of black plexiglass that reflected everything in the set. Both the model and the equipment had to be carefully placed so that all the necessary information was conveyed, even in silhouette.

The flash exposure was calculated to be *f*-11. At that aperture, I needed to give an exposure time of 2 seconds for the screen image. In order to avoid image blur due to possible movement by the model, I made the exposure with all lights—including the flash modeling light—turned off. ☐